IMAGES
of America

DATELINE
GREENSBORO
THE PIEDMONT AND BEYOND

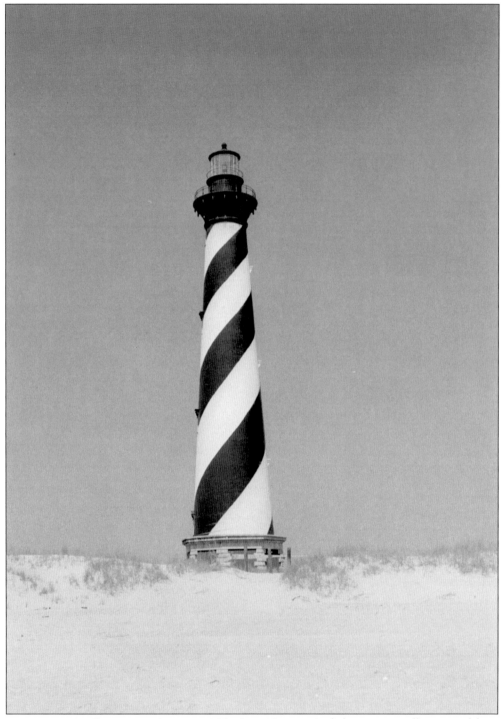

JUNE 25, 1953. THURSDAY. BUXTON, NC. Cape Hatteras Lighthouse was well protected from the ocean when Martin photographed it 50 years ago on a trip to the Outer Banks. The entire world watched in 1999, however, when this historic 1870 structure was moved 2,900 feet inland to ensure its long-term preservation.

IMAGES
of America

DATELINE
GREENSBORO
THE PIEDMONT AND BEYOND

J. Stephen Catlett

ARCADIA

Published by Arcadia Publishing,
an imprint of Tempus Publishing, Inc.
2 Cumberland Street
Charleston, SC 29401

Printed in Great Britain.

Library of Congress Catalog Card Number: 2002110801

For all general information contact Arcadia Publishing at:
Telephone 843-853-2070
Fax 843-853-0044
E-Mail sales@arcadiapublishing.com

For customer service and orders:
Toll-Free 1-888-313-2665

Visit us on the internet at http://www.arcadiapublishing.com

This book is dedicated to the three people who continue to inspire me:
Leslie, Evan, and Jean-Marie.

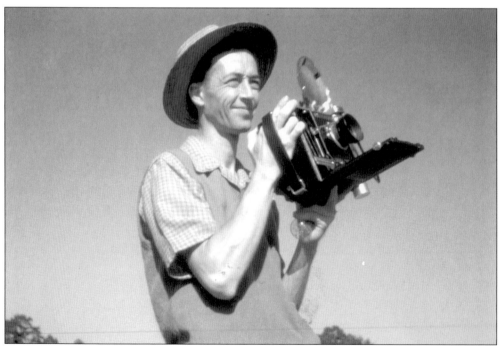

CIRCA 1940. GREENSBORO, NC. This photograph of Carol W. Martin was made from a rare Kodachrome color slide.

CONTENTS

Acknowledgments 6

Introduction 7

1. On the Job 9

2. The 1930s 17

3. The 1940s 29

4. Wednesday May 19, 1948 43

5. The 1950s 49

6. Tuesday June 2, 1953 63

7. The 1960s 69

8. Saturday October 14, 1961 87

9. A Window on Greensboro: 1940 and 1989 93

10. Maybe the Next One 107

Index 126

ACKNOWLEDGMENTS

There are many people who deserve thanks for assisting me in launching this second volume of Martin's Studio photography. Laura New, at Arcadia, has remained enthusiastic and supportive from the beginning and helped make the process much more enjoyable. I treasure the support over the last ten years from the Martin family, especially from Carol's wife Ruth and his son Jim. They have been generous to me and very supportive and appreciative of the museum's commitment to preserving and promoting the Martin's Studio collection. Carol is missed daily, but the wonderful thing about a visual artist is that long after they are gone you can still live in the midst of their art. Since my first book, I have grown to appreciate even more Malcolm Miller's calm, professional demeanor, which helped the studio weather even the most crazy, hectic workdays. I thank Mrs. Greta Tucker for sharing her memories of Clarence and his contributions to the success of the studio.

The reference staff at the Greensboro Public Library, especially Helen Snow and Tim Cole, were particularly helpful, and I appreciate the support of Brigitte Blanton. Thanks to Stephen Massengill at the North Carolina Division of Archives and History and Walter Turner at the North Carolina Transportation Museum. Mr. Jimmy Cheek was very helpful in identifying and providing information about the Daydreams. I also want to thank Bill Moore, director of the Greensboro Historical Museum, who has remained a supporter of the Martin's collection and projects since the very beginning. Museum Shop manager Betty Montgomery's enthusiasm for a new book helped convince me to "go for it."

Finally, I want to thank my wife, Leslie, for enduring several months of inattention, as well as many late nights of a clicking keyboard. Creating a book is mostly a solitary venture, but creativity does not arise without the love and support of many people, including those most dear to you.

MARTIN'S STUDIO RECORDS. The Martin's Studio collection contains documentation on many of the photographs.

INTRODUCTION

With the opening of the exhibit "Martin's Studio: Greensboro's 'Story Telling' Photographers" at the Greensboro Historical Museum in 1999, and the companion Arcadia book, *Martin's and Miller's Greensboro*, about 300 unique images from the Martin's Studio collection were presented to the public. With an archive of over 200,000 negatives, that only scratched the surface. In my mind that was sufficient to justify another book, but being an admirer of the photography of Carol Martin and Malcolm Miller is not necessarily enough to convince a publisher. The challenge, I thought, was to create a new approach, not just new categories with new photographs. My first book, like the exhibit itself, followed a subject approach with photographs grouped into chapters such as "Sports," "Children," and "School Life." The images were almost exclusively of Greensboro and Guilford County and followed no particular chronological order. It was relatively easy to organize and worked extremely well both for the exhibit and the book. In looking back, however, I realized that a topical approach, for all its advantages, sacrifices the opportunity to visualize life over time. The dynamic of the workplace is also lost, in this instance a full appreciation of the extraordinary variety of jobs the studio undertook and completed on a daily basis in Greensboro and across the state.

Even in their earliest days on the newspaper, and certainly during their studio years, Martin and Miller were "assignment" photographers, pure and simple. They had freedom to be creative on individual jobs but they were not free, like documentary photographers, to undertake a comprehensive visual history of their community. Yet, when you look at their 50-plus years of daily production, it is obvious that they still ended up creating an amazing visual record of late 20th-century life.

This book represents my tribute to their relentless, professional work ethic, which drove them to their next job, their next image; to amassing a body of work, which I believe has few equals anywhere. To this end, three unique chapters will offer you the opportunity to see what was happening on a single day and experience, on an hourly time-line, their entire day's production. It is a chronological journey offering a glimpse of 20th-century life in Greensboro, the Piedmont, and beyond.

8

One

ON THE JOB

As the author's 1999 biographical sketch in Martin's and Miller's Greensboro *detailed, Carol W. Martin was the principal owner of Martin's Studio and a seasoned, 36-year-old professional photographer when he and Malcolm A. Miller set up their private photographic studio full-time in February 1947.*

Martin was a native of Virginia and came to the Greensboro Daily News *from the* Roanoke Times *in 1938 as the paper's first full-time photographer. Miller, on the other hand, had been a part-time photographer for only two and a half years when the studio opened. He was six years younger than Martin and a fast learner, having gained valuable experience under Martin's watchful eye at the newspaper. He was tall, quiet, and laid back; Martin was hard charging and engaging. In other words, their personalities meshed perfectly, and they worked hard the first year trying to build Martin's Studio into a thriving business. They brought with them their newspaper and "society page" contacts, which was a real asset, bringing in lots of portrait and wedding work. They also continued to do contract work for the newspaper for a while, and Miller aggressively cultivated the business accounts. To top it off, because Martin had been a charter member of the Carolinas Press Photographers Association in 1938, and had served as its president in 1940–1941, he was well known across the state, which brought work to the studio from well beyond Greensboro and Guilford County. In fact, soon the jobs were piling up in the darkroom so fast that they hired Miller's brother-in-law, Clarence Tucker. As it turned out, Tucker ended up as the studio's first and only lab technician.*

The photographs in this chapter offer glimpses of what life on the job meant for Carol Martin, Malcolm Miller, and Clarence Tucker.

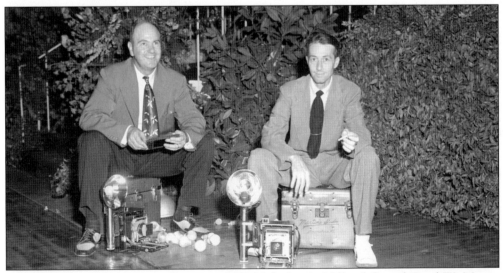

SEPTEMBER 7, 1951. FRIDAY. RALEIGH, NC. Malcolm A. Miller, left, and Carol W. Martin take a break at the North Carolina Debutante Ball. Big photo shoots like this left mounds of spent flash bulbs, so they usually left a $1 bill under the pile for the cleaning crew.

9

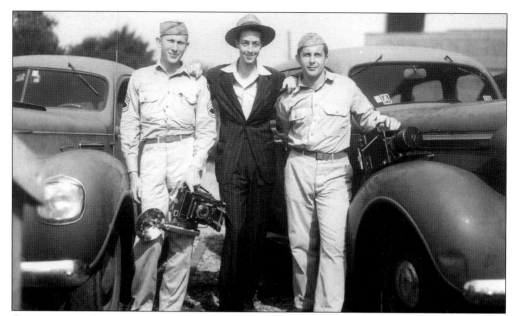

CIRCA 1943. GREENSBORO, NC. Grover C. Niles Jr., left, and Russell Raines flank Carol Martin. They were Army Air Force photographers with the 47th Bombing Group, stationed at Basic Training Center #10. This 650-acre base opened inside Greensboro's city limits in March 1943 with no darkroom or equipment. These aerial trained photographers knew almost nothing about taking photographs of people, but Martin gave them expert instruction in photojournalism, and the *Daily News* loaned their lab and cameras to get them going.

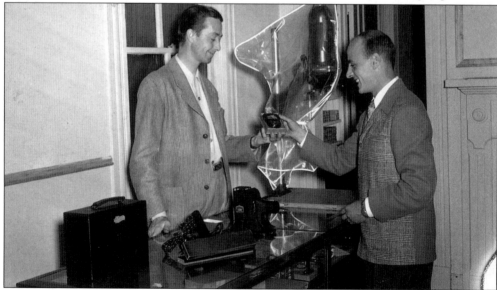

CIRCA 1946. GREENSBORO, NC. Martin is assisting Jerry DeFelice, who was the principal military photographer at BTC #10. "The Darkroom," seen here at 116 West Sycamore, was the first name of the studio, which opened as a part-time business in 1946. Miller suggested capitalizing on Martin's name by changing it to "Martin's Darkroom." For a short time they sold photographic equipment and supplies, but they soon realized that taking photographs is what they really loved. They sold off the equipment and never looked back.

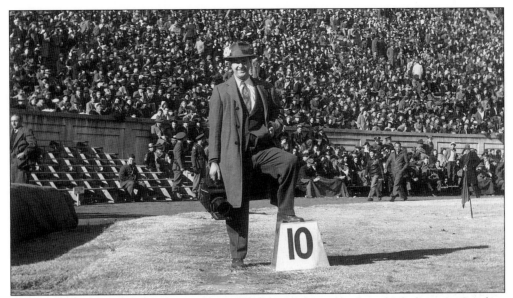

FALL, 1947. CHAPEL HILL, NC. Malcolm Miller is in his normal work clothes at a Carolina Tar Heels football game. Miller, a native of Greenville, South Carolina, had come a long way as a photographer in just three years. From a Cone Mills loom fixer, who took photographs around town as a hobby—developing and printing them in a converted "chicken house" darkroom behind the family home—Miller was now a full-time photographer and part-owner of a studio that was quickly becoming known across the state.

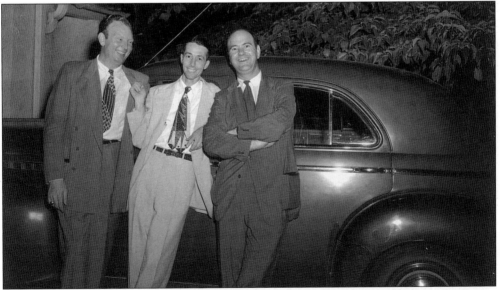

THE 1940S. GREENSBORO, NC. Clarence Tucker, left, was responsible for Miller getting his first big photographic break. On July 24, 1944, Tucker called to say that First Lady Eleanor Roosevelt was at the railroad depot. No one knew she was in town. This led quickly to Miller taking her photograph, developing and printing it at home, taking it to the newspaper, getting it published the next day, and the call about two weeks later asking him if he would like to come work part-time with Carol Martin. It also led to his lifetime retort, "Eleanor Roosevelt got me my first job!"

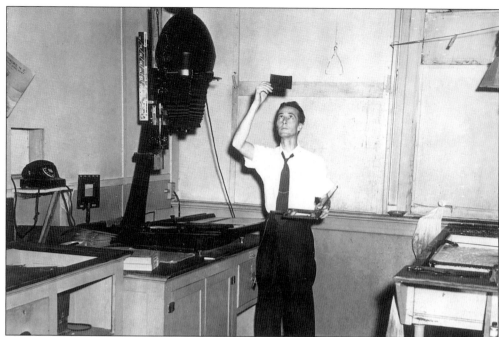

THE 1940s. GREENSBORO, NC. Carol Martin examines a negative in the darkroom of their first lab on Sycamore Street. Martin, a native of Roanoke, Virginia, was an energetic, ambitious photographer who came to Greensboro thinking he would stay a few years and move on to Atlanta or Richmond. But as he later said, "I got to love this town, got married, and started raising children."

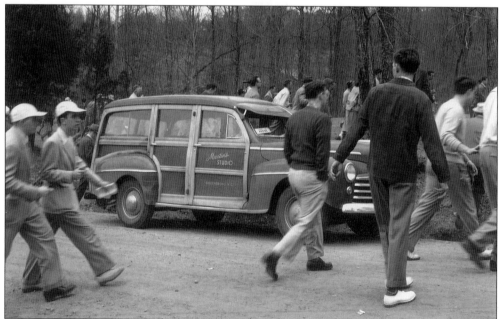

THE 1940s. SEDGEFIELD, NC. The Martin's Studio station wagon is pictured at the Greater Greensboro Open golf tournament. In the early years the studio racked up a lot of miles on their vehicles since they were getting assignments from all over the state.

CIRCA 1950S. GREENSBORO, NC.
In 1948 the studio moved to bigger
quarters in this building at 112 East
Gaston (now Friendly Avenue).
They expanded this space in 1956,
adding two air-conditioned rooms
necessary for their color lab, which
was the first one in town. They
remained there until 1966, when it
and the Gulf gas station next door
were demolished for a new parking
deck. They moved to the building,
visible on the lower left, where they
remained until the business closed

CIRCA 1950S. GREENSBORO, NC.
Malcolm Miller stands in front
of the Gaston Street studio with
his camera, tripod, and lights. In
the early 1960s people used to stop
and marvel at Miller, who crammed
this and even more photographic
gear into his subcompact
Volkswagon Beetle.

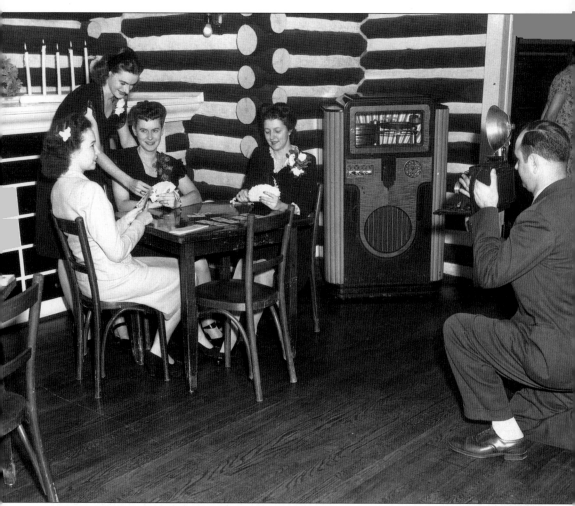

CIRCA 1950S. GUILFORD COUNTY, NC. Miller photographed these Jefferson Standard Life Insurance Company employees at the company's clubhouse in western Guilford County. Miller handled the majority of the studio's industrial and business accounts, especially the Jefferson Standard work. In the early years these Speed Graphic or Graflex cameras were used and although portable, required strong hands, arms, and back. Their real beauty was in their lenses and the large 4x5 inch negatives they produced. The large surface area made touching up the negative in the lab much easier. Also, if you held the camera steady, which they almost always did, the resulting image quality was superb, even at great enlargement.

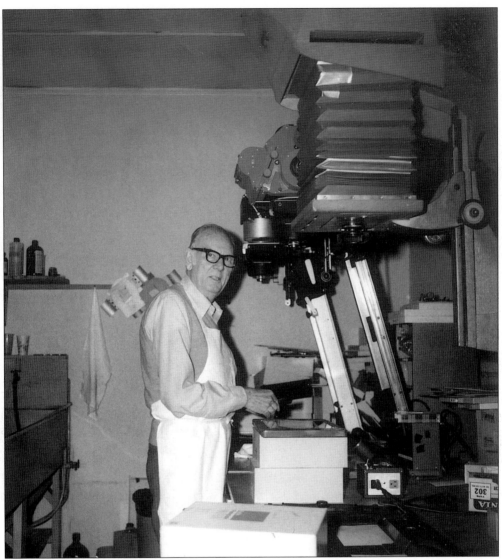

DECEMBER 29, 1983. THURSDAY. GREENSBORO, NC. Unlike Martin and Miller, Clarence N. Tucker was a native of Greensboro, having been born in the city in 1916. His brother-in-law connection to Miller certainly helped him get the lab technician job in 1947, but he came to the studio with some amateur photographic experience and was a hard worker and quick study in photography and darkroom technique. His knowledge of the city was an asset, too, as was his good eye and deft touch in the lab, where the art of retouching prints and negatives does not come easily to everyone. In the early years Tucker—who shared Miller's easygoing personality—occasionally took some of the same photographs he printed, since he would fill in if Martin or Miller were away, or if it was a particularly busy day. And he even took photographs at some of the area nightclubs, usually with his wife Greta's assistance. Tucker continued to learn and improve over the years, in part by attending professional meetings with Martin and Miller and also by seeking out additional training, like the professional seminars put on by Kodak in Atlanta. Malcolm Miller recently observed, as he reflected on Tucker's darkroom expertise and contributions to the business, that "he was the best photographic printer" he had ever known. Tucker died on October 21, 1987, after a 40-year career at Martin's Studio.

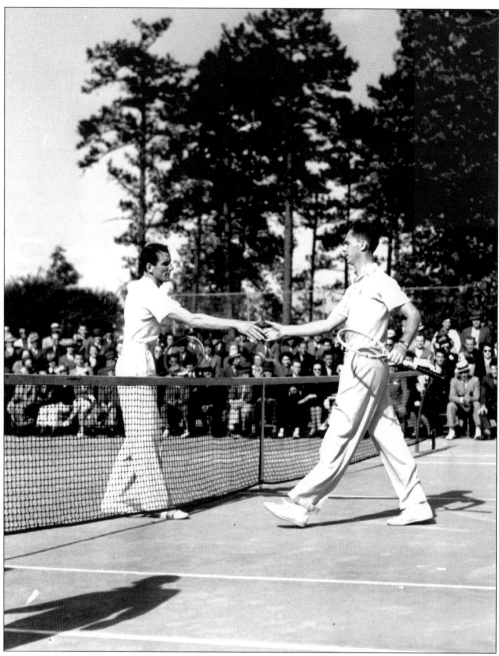

MAY 15, 1938. SUNDAY. SEDGEFIELD, NC. Two major 1930s professional tennis champions—
Great Britain's Fred Perry, left, and American Ellsworth Vines—played a match at the
Sedgefield Country Club before about 2,000 spectators. This was one in a series of matches
they played for the right to face Don Budge, the world's ranking amateur (and first to win the
grand slam) who was expected to turn pro in the fall. Most of the spectators came to see tennis,
but many probably also showed up to see Perry's wife, Helen Vinson, who was a major movie
star of the era.

Two

THE 1930S

When Carol W. Martin came to Greensboro in early 1938 he moved to one of North Carolina's major cities. Covering 18.06 square miles, its population totaled over 59,000. It was no cultural melting pot, however, since 99.8 percent of the population was American born. On the other hand it was a youthful city, with 50 percent of its citizens under 30 years of age and only 6 percent over 60. This had to appeal to the 26-year-old Martin, as did the fact that his $35-per-week salary in Greensboro was $10 more than his Roanoke pay. And there was plenty to spend it on, even during these Depression years. With close to 700 retail stores, Greensboro ranked third in the state in total sales. There were 7 movie theaters, 19 parks with 425 acres, 5 colleges, 15 hotels, 5 hospitals, and 32 passenger trains arriving and departing daily. The city had an automobile population of over 11,000 vehicles, with 138 miles of paved streets to navigate.

Although the Daily News continued to use part-time photographers over the years, most of its local and regional photographs between 1938 and 1946 gave credit to "C.W. Martin." It is arguable whether words or photographs were more important to readers and publishers in 1938, but the hiring of Martin is a good indication of the growing importance of visuals in selling newspapers. The Daily News began to capitalize on Martin's availability and talent right away, not only publishing individual images but running multiple photographic "spreads," like the feature on the rural pastime of frog gigging, illustrated on pages 25 and 26. This book resurrects other rare photographs and corresponding captions, which have not been seen since their initial appearance over a half-century ago.

JANUARY, 1938. GREENSBORO, NC. Martin took this image from the Jefferson Standard building and years later wrote this caption: "Old Federal building for sale. It stood on the southeast corner of Elm and Market, where later Belk's was built."

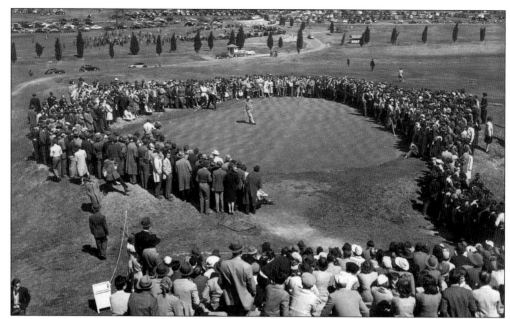

MARCH 26, 1938. SATURDAY. GREENSBORO, NC. This view captures action from the first Greater Greensboro Open golf tournament. Taken from the roof of the Starmount Forest Country Club, it shows the ninth green and some of the 6,000 spectators who came out that day. A newspaper add promoted the $5,000 tournament as "North Carolina's Richest Sporting Event." Enjoy Greensboro's "fine stores, hotels and restaurants," and you might also "improve your golf game." Seven former national open champions played, but it was won by Sam Snead—the first of his record eight GGO titles.

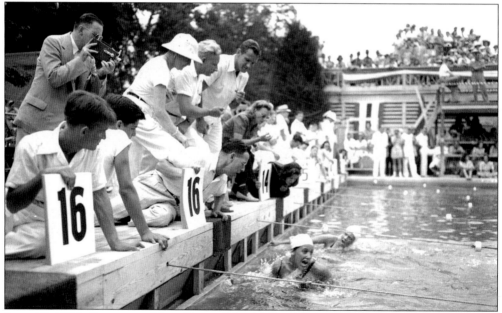

JULY 15, 1938. SATURDAY. HIGH POINT, NC. The fourth annual Carolinas AAU Swim Meet at the High Point Lake swimming pool attracted swimmers from all over the east coast, including teams from as far away as Philadelphia.

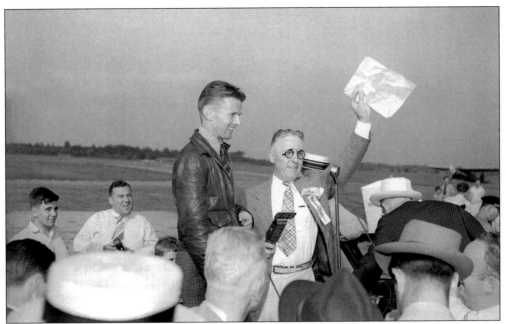

AUGUST 27, 1938. SATURDAY. GREENSBORO, NC. Douglas "Wrong Way" Corrigan visited Greensboro six weeks after his "wrong way" flight across the Atlantic Ocean to Ireland, which had seen him "mistakenly" fly east after his flight plan was denied. Although duplicating in part Charles Lindbergh's historic 1927 journey, Corrigan's adventure was soon relegated to history.

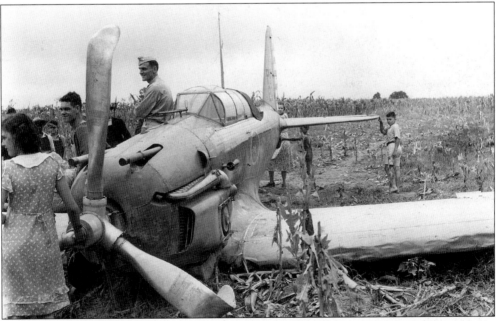

SEPTEMBER 3, 1938. SATURDAY. GUILFORD COUNTY, NC. This was published the next day in the *Daily News* with the caption "Unhappy Landing." Seen is pilot Lt. J.R. Ambrose, who was forced to make a crash landing in dense fog and rain, in a corn field north of Greensboro. Ten other pilots also were forced down that morning, with two having to bail out when their planes fell near Reidsville.

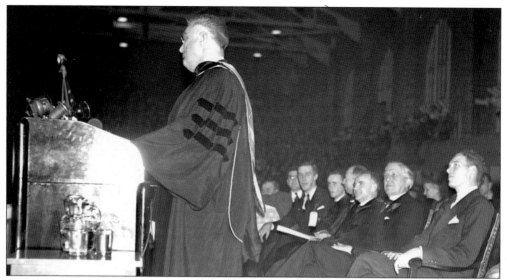

DECEMBER 5, 1938. MONDAY. CHAPEL HILL, NC. Before a packed crowd at Wollen Gym, President Franklin D. Roosevelt received an honorary doctorate, as Governor Clyde Hoey, second from right, looked on. Responding to his political opposition's criticism of him as a warmonger and socialist, who dined every morning on a dish of "grilled millionaire, " FDR responded with his typical flair. "I am an exceedingly mild-mannered person—a practitioner of peace, both domestic and foreign, a believer in the capitalistic system and for my breakfast a devotee of scrambled eggs."

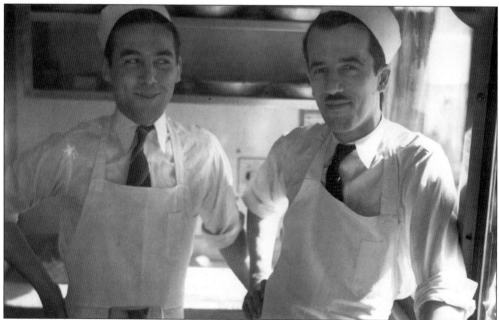

DECEMBER, 1938. GREENSBORO, NC. The Puritan Café at 218 North Elm Street, located next to the Elm Theatre, was a popular diner from the 1920s until the mid-1950s. Harry Pappas, right, was one of its many Greek owners and managers over the years, along with Peter Blakas, Spiros Phillos, and Gus Demetrelis. Greensboro diners were apparently not that adventurous then, since the Puritan advertised itself as "Famous for Western Steaks."

DECEMBER, 1938. GREENSBORO, NC.
Everett N. Hale, pressman for the
Greensboro Daily News, inspects a
"hot off the press" paper. Hale began
as a "helper" for the *Daily News* in
1921 and worked almost 50 years
before retiring around 1969. During his
career the presses printed not only the
Daily News but also the afternoon
Greensboro Record.

**FEBRUARY 11, 1939. SATURDAY.
GREENSBORO, NC.** The Fire
Department's main station on north
Greene Street was a state-of-the-art
facility when it opened on May 15,
1926. It housed four engine companies,
with large sleeping quarters on the top
floor, requiring the traditional poles so
the firemen could get downstairs in a
hurry. By 1939 the department had 5
total stations, 71 men, and 13 pieces of
motorized equipment. As for Central
Station, it remained at this location
until 1980, when the new station and
training center opened on north
Church Street.

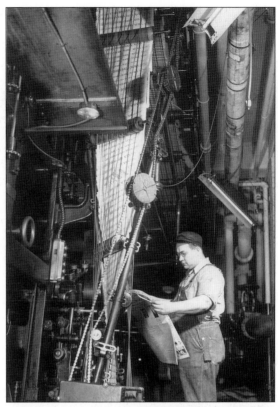

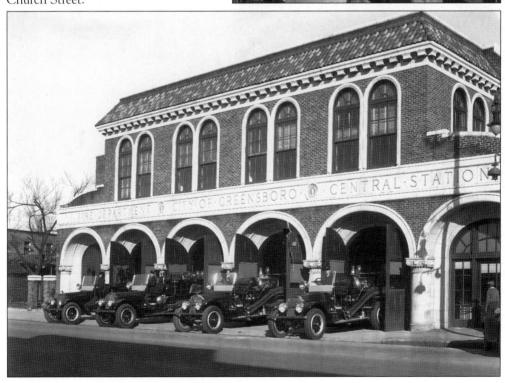

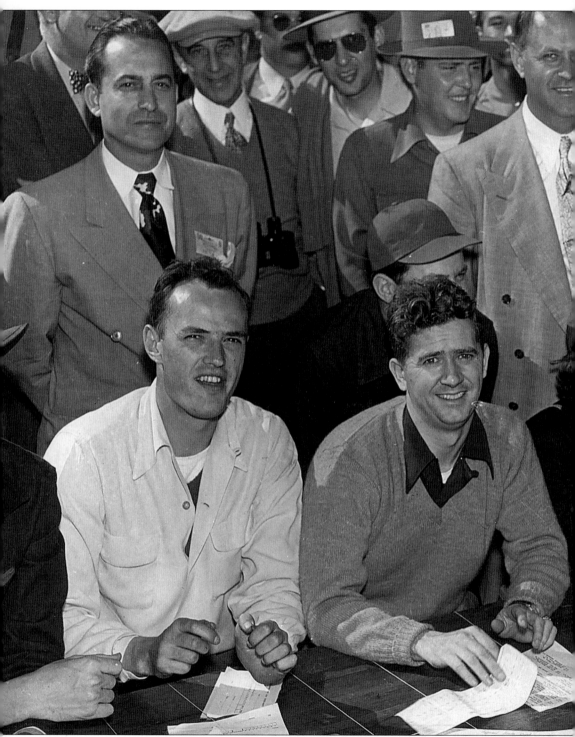

MARCH 25, 1939. SATURDAY. SEDGEFIELD, NC. Sam Snead hands in his scorecard to Junior Chamber of Commerce secretary Nancy Sewell and JC scorer Tom Cribbin. After winning the inaugural tournament the year before, Snead finished 21st and out of the money in defense of

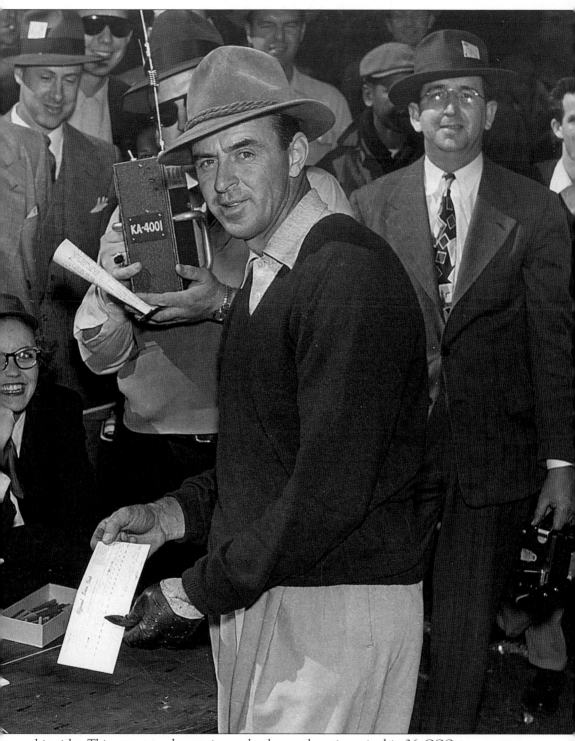

his title. This was rare, happening only three other times in his 36 GGO tournaments. Who won? Ralph Guldahl, the two-time U.S. Open champion shot a 280, beating Lawson Little by 3 strokes.

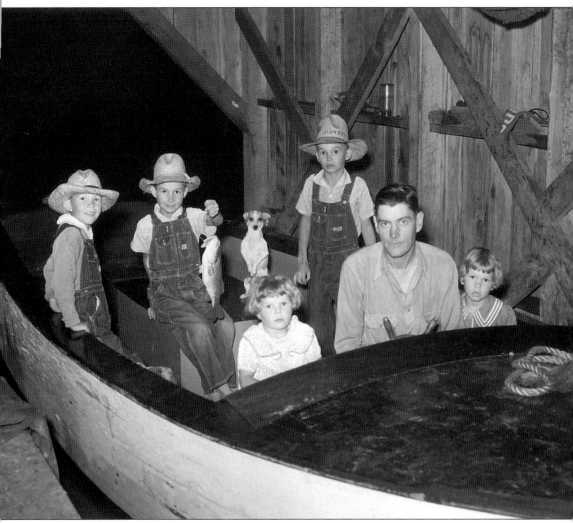

SUMMER, 1939. GREENSBORO, NC. Martin got everyone's attention, even the dog's, before he snapped this image of E.C. "Ned" Dillard and his five children. Dillard was the Lake Brandt warden for many years.

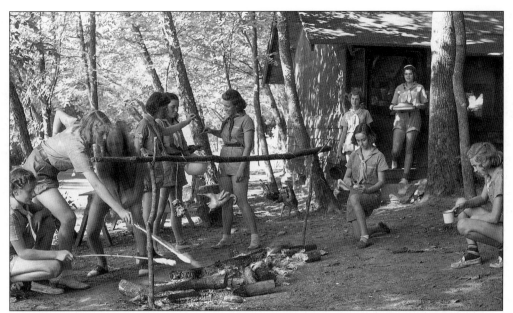

SUMMER, 1939. BIG ALAMANCE CREEK, GUILFORD COUNTY. Some 800 Girl Scouts made the 14-mile trip that summer out to the Old Mill Camp east of Greensboro. Its name came from the old Foust Mill, which served as the camp's main lodge. A big improvement that summer, although not visible here, was the electricity that had been extended to the camp, compliments of the Exchange Club. What is evident is the perennial favorite, the marshmallow roast.

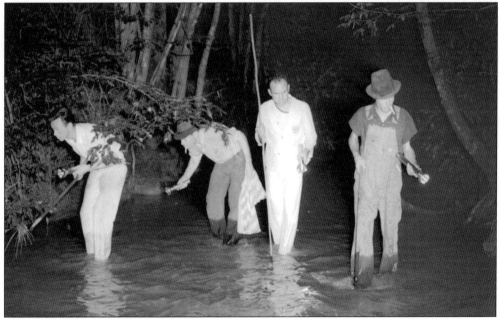

AUGUST 5, 1939. SATURDAY. GUILFORD COUNTY, NC. The *Greensboro Daily News* reported that frog gigging, which had been "a rural pastime of first magnitude," was spreading to urban communities. They sent Martin on his first gigging expedition in an attempt to give the readers a look "at the gentle art of capturing the amphibian whose rear legs are considered a delicacy by many."

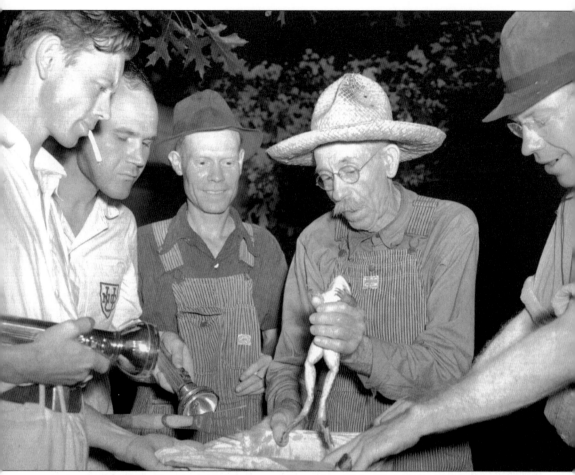

AUGUST 5, 1939. SATURDAY. GUILFORD COUNTY, NC. The *Daily News* caption read: "Madry Simmons, left, and Stuart Sechriest, holding flashlights, while Uncle Dan'l Frazier, veteran of many frog gigging expeditions (shown wearing the large straw hat) is in the act of transferring a large, juicy frog, just caught, to the bag while Glenn Frazier, at Uncle Dan'l's left, and Rufus Frazier, extreme right, look on."

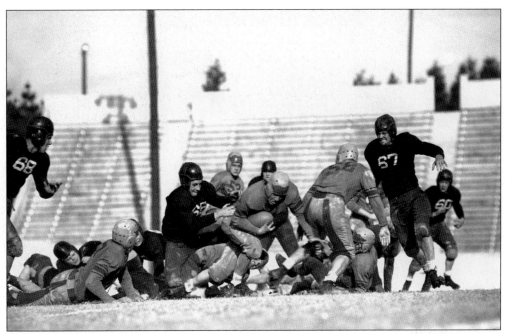

FALL, 1939. WINSTON-SALEM, NC. Lexington High School, in light colors, is seen going for yardage against the Children's Home team.

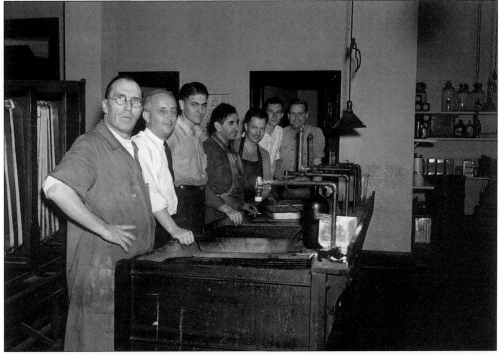

FALL, 1939. GREENSBORO, NC. Creating graphics for the newspaper, which was the job of these men in the engraving department at the *Daily News*, was a more labor intensive and dirty job than is the case today. Although they did not have PCs, Macs, or Adobe PageMaker in those days, they were no less creative, only more limited in the tools at their disposal.

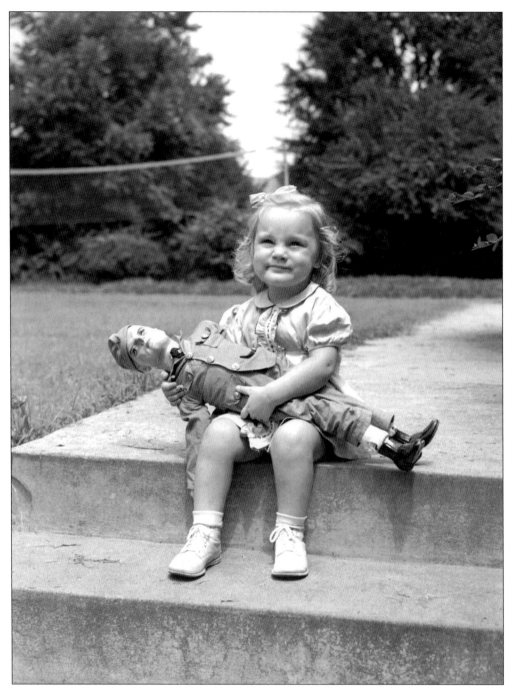

THE 1940s. GREENSBORO, NC. World War II was a life changing experience for even the smallest citizen. It brought more anxiety and sadness than joy. More often a photograph or letter, perhaps even a doll, substituted for a husband or son, or perhaps a father. And if you were extremely lucky, one day you put the doll on the shelf, wrapped your arms around your father's neck, and never let go.

Three
THE 1940s

This was a tumultuous decade and the images in this chapter capture the compressed, almost schizophrenic quality of life between 1941 and 1945 and in the post-war years that followed. The photograph at left shows with emotional simplicity what the defense of democracy meant to every village, town, and city in America. But that storm was two years away when the decade broke, and the calm and normalcy that preceded it comes through clearly in the photo of the 1941 GGO golf tournament below, and the images that follow of the bountiful peach harvest the following summer in the Carolina sandhills.

Yet even after Pearl Harbor yanked America out of its complacency into the brutality of a world at war, life at home continued. It may have meant the Rose Bowl had to be moved for the first and only time from the west coast to Durham, North Carolina; that children gave up their innocent, juvenile, competitive games to organize and collect scrap metal for weapons of war; that a city like Greensboro would, almost overnight, become an important military town, with a base hosting over 300,000 soldiers. It may have meant and brought all of that—as the images in this chapter show—but they also show that life went on. But if life before the war was somewhat more carefree, the war brought a life of roller coaster emotion lived on the edge between hope and fear. We do not know which came to pass for the girl at left, her hopes or her fears. But the photographs in this chapter do highlight some of the everyday events and help us understand how it changed our society. People emerged from the experience appreciating life, home, and country like never before, but also understanding that life can instantly be cut short.

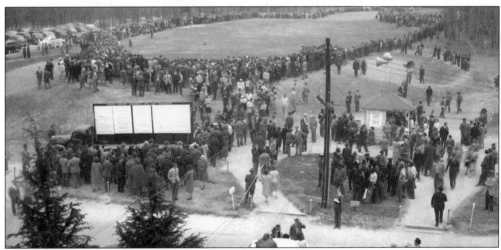

MARCH 23, 1941. SUNDAY. GREENSBORO, NC. A record gallery witnessed the final round of the Greater Greensboro Open at Starmount Forest Country Club. This image, published the next day, highlighted Byron Nelson's victory. He shot a 70, beating Vic Ghezzi by two strokes and taking home the $1,200 purse. The Jaycees netted $2,800 from the tournament. Although Pearl Harbor came nine months later, the tournament was held in 1942 but was then suspended until 1945.

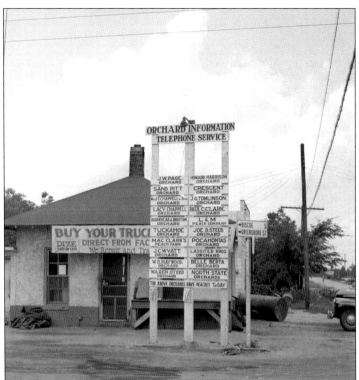

JULY 27, 1941. SUNDAY. CANDOR, NC. The *Greensboro Daily News* ran a major feature that day, written by E.B. Jeffress, with the headline: "Peach Harvest Now At Height." The nine Martin images documented, in fascinating detail, this important regional and state industry. The caption for the image here read as follows: "This sign board stands at the cross roads in Candor. It furnishes information as to which orchards have peaches on a particular day."

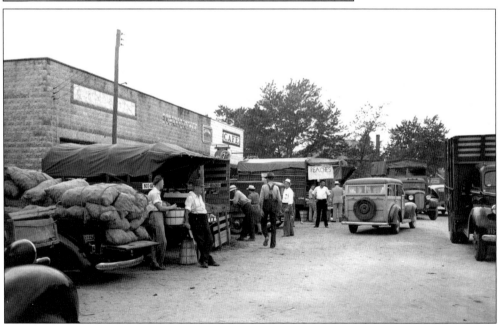

JULY 27, 1941. SUNDAY. CANDOR, NC. "In The Peach Capital," read the caption. "This is a section of the curb market at Candor where every day in the week numbers of trucks back up to the curb with loads of produce. Here one can purchase not only peaches but also cantaloupes and watermelons. It is one of the largest curb markets in the state and is a familiar sight to travelers on the highways through Candor."

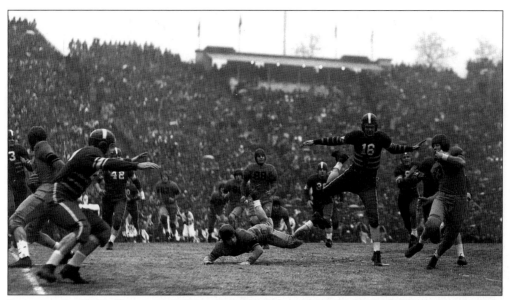

JANUARY 1, 1942. THURSDAY. DURHAM, NC. The only time the Rose Bowl game has not been played in California was this game, moved to Durham after the Japanese attack on Pearl Harbor the month before. The next day's caption read: "Don Durdan, No. 39, brilliant triple threat Oregon State halfback, gets off a long gain in the second quarter . . . Capt. Bob Barnett, senior Duke center, hurdles a player to pull down Durdan on his jaunt around end, one of his many sparkling sprints." The unbeaten Duke team lost the game, for the second time in three years, 20 to 16.

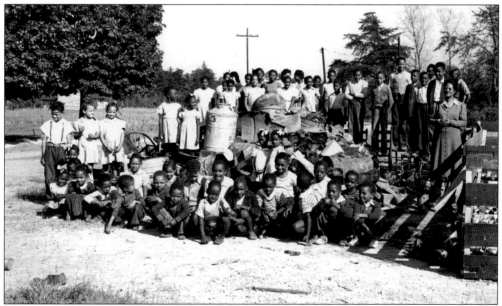

CIRCA 1942. GREENSBORO, NC. These school children were participating in one of the early scrap drives of the war, possibly the November 1942 effort that collected over 311,000 pounds. This came after President Roosevelt challenged the youth of America to "perform a great patriotic service" by collecting all sorts of metals, rubber, rags, and even tinfoil from chewing gum and cigarette packs.

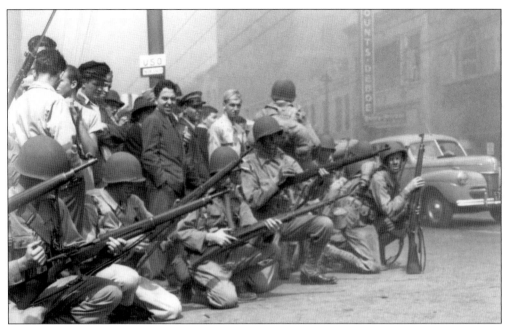

SEPTEMBER 24, 1943. FRIDAY. GREENSBORO, NC. Soldiers from Camp Butner and the local Basic Training Center #10 "invaded" Greensboro with jeeps, half-tracks, and all types of weapons. This military exercise included house-to-house fighting and the "capture" of vital installations like city hall and the telegraph office. It promoted not only basic training, but also the Carolina Theatre premier five days later of the major motion picture *This Is The Army*.

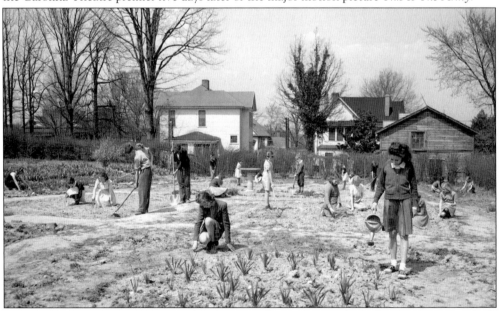

CIRCA 1943. GREENSBORO, NC. The planting of "Victory Gardens" during WWII was both patriotic and important for the food supply. It has been estimated that up to 20 million gardens were planted, yielding as much as 40 percent of the country's vegetables. If the yield for many of these novice gardeners was not that large, "doing one's share" on the home front was almost as important a product as were the vegetables themselves.

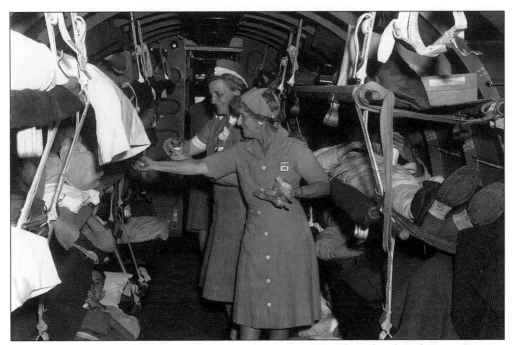

SEPTEMBER 25, 1944. MONDAY. GUILFORD COUNTY, NC. These local Red Cross Canteen Aide volunteers—Mrs. Benjamin Bates in front—are assisting wounded soldiers onboard a Red Cross plane parked at Lindley Field (today's Piedmont Triad International Airport).

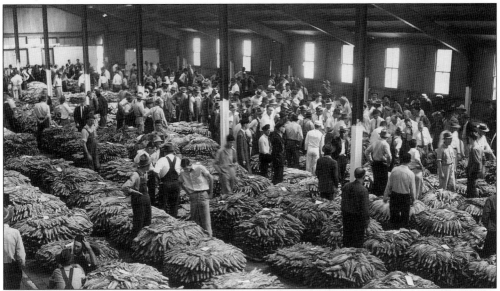

SEPTEMBER 28, 1944. THURSDAY. REIDSVILLE, NC. This tobacco auction was opening day of the market at Reidsville in Rockingham County. Reidsville has a long history as a tobacco and cigarette center, dating back to the 1910s and the construction of the Lucky Strike cigarette factory by the American Tobacco Company. The tobacco industry was a major economic generator for the 20th-century Piedmont. The 1940 figures for Rockingham County are very telling in this regard, with total agricultural income for tobacco at $2.7 million, corn at $365,278, and vegetables at $296,785.

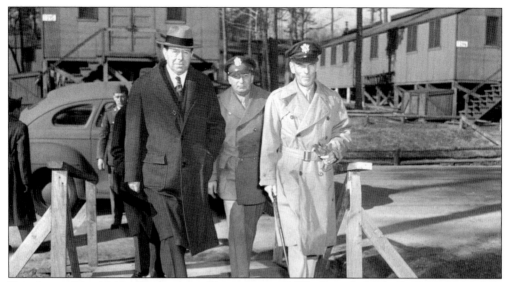

DECEMBER 21, 1944. THURSDAY. GREENSBORO, NC. Gov. J. Melville Broughton, left, inspected the Overseas Replacement Depot (ORD) with Maj. Gen. Hubert R. Harmon. Col. Paul Younts, base commander, is between them. ORD was a 650-acre military base inside the city limits. Over 300,000 soldiers came through Greensboro, most headed for action in the European or African theatres of war. Harmon told 2,500 soldiers that when he was on Guadalcanal "there was a saying that you could throw a stone in any direction and hit a North Carolinian . . . but no one throws stones at North Carolinians."

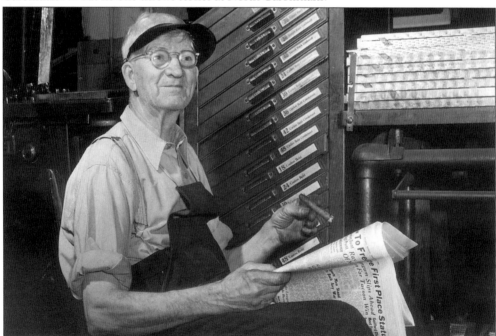

JANUARY, 1945. GREENSBORO, NC. Elisha H. "Pop" Crawford was a longtime linotype operator for the *Greensboro Daily News*. He joined the newspaper around 1912 and worked there for over 40 years. "Pop" was not only an affectionate name, but a necessary one, since two of his sons also worked at the paper: Pat in engraving and Jim in the mechanical department.

MARCH 2, 1945. FRIDAY. GREENSBORO, NC. A packed house witnessed action in gymnastics and basketball at the meet held at Rosenthal Gym at Woman's College (now UNCG). Going up for a basket, as hundreds of students looked on, was Peggy Clemmer of Sanford.

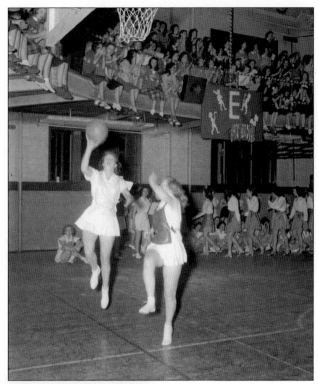

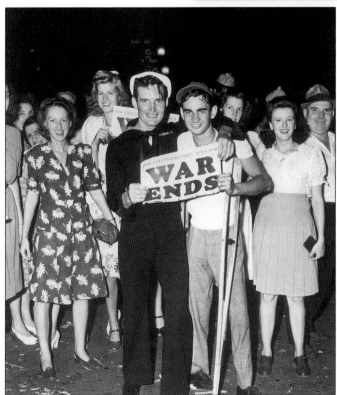

AUGUST 14, 1945. TUESDAY. GREENSBORO, NC. Relief, joy, and wild celebration exploded across Greensboro, America, and the world, on this historic night. It all happened within minutes of President Harry Truman's announcement that Japan had accepted Allied surrender terms. World War II was over! Housewife Beth Puckett wrote her husband Lewis a letter later that night, saying "It's over . . . I just keep repeating 'it's over'."

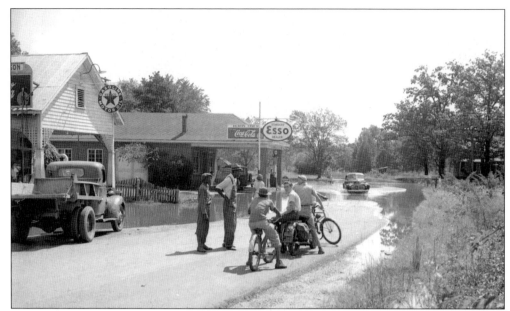

SEPTEMBER 19, 1945. WEDNESDAY. GULF, NC. Devastating floods ravaged North Carolina, in what the *Daily News* reported as one of the worst floods in the state's history. Martin was sent south, toward Gulf and Sanford, to record the damage along the Deep River, and his images were published the next day. The raging waters completely destroyed Sanford's municipal dam, and reached 66 feet—31 feet above flood stage—along the Cape Fear River at Fayetteville.

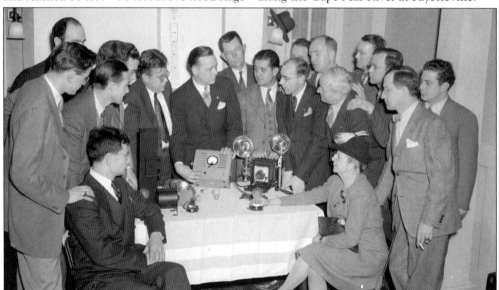

FEBRUARY 17, 1946. SUNDAY. PINEHURST, NC. The Carolinas Press Photographers Association attracted some of the state's most accomplished photographers, who mixed socializing with the chance to learn about new equipment for the still relatively new profession. Carol Martin (standing, third from left) was in attendance, as was Malcolm Miller (standing, far left with face obscured). The woman seated at right is Bayard Wootten of Chapel Hill, the noted North Carolina and regional photographer, who is considered one of the state's most significant 20th-century photographers.

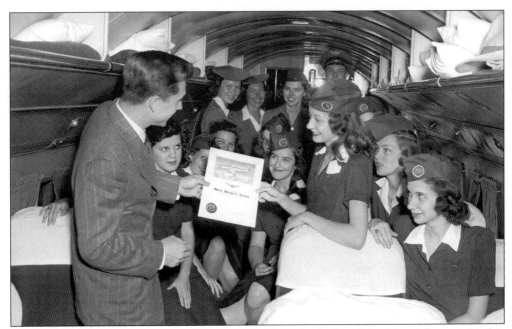

JUNE, 1946. GUILFORD COUNTY, NC. As stewardesses looked on, Miss Mary Margaret Ritchie received a certificate as "Honorary First Officer of the PCA Capital Fleet." Air travel began to expand significantly after WWII and Pennsylvania Capital Airline, which later became part of United Airlines, added stops at Lindley Field outside of Greensboro (today Piedmont Triad International Airport). The romance of flying was still fresh and exciting 60 years ago, which made it an attractive job for young women.

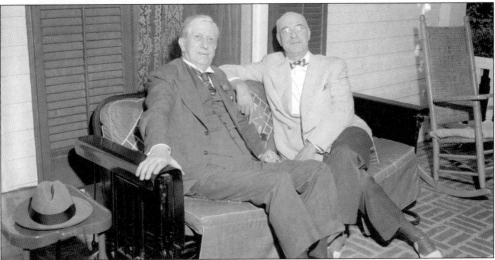

SEPTEMBER 12, 1946. THURSDAY. SHELBY, NC. This image was published on the 15th, with the caption "Senator Clyde R. Hoey, left, and O. Max Gardner, undersecretary of the treasury, both former Governors of North Carolina who call Shelby home . . . are shown here in an informal shot as they rested in their home town for a few days' vacation following strenuous work in Washington." They were convinced the common folk like those in Cleveland County were the backbone and hope of the nation. "It's surprising," said Gardner, "how much more sense they have than a lot of statesmen."

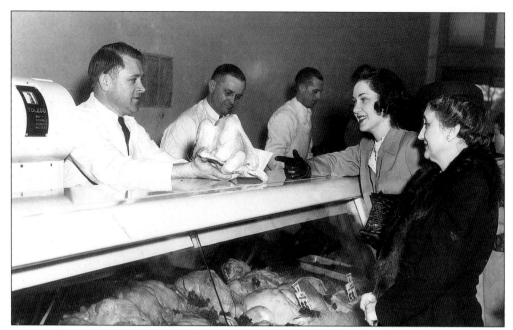

FALL, 1946. GREENSBORO, NC. This image captures the first sale of non-rationed meat at the A&P, then located on Commerce Place in downtown Greensboro. The buyers are Mrs. William Wine, left, and her mother, Mrs. S. Graham Wimbish.

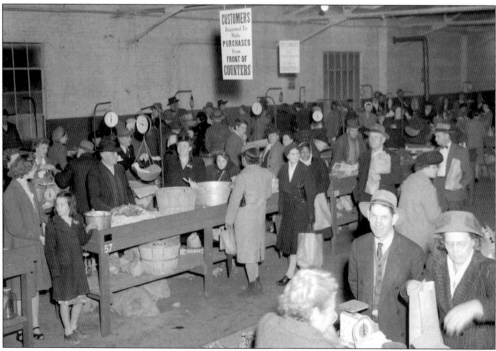

SUMMER, 1947. GREENSBORO, NC. Shopping at a farmer's curb market has been popular for generations. One point of interest in this image is the style of clothing worn by the shoppers and vendors. It was generally true during this era that going shopping downtown—this market was located at 229 Commerce Place—meant dressing up, not down.

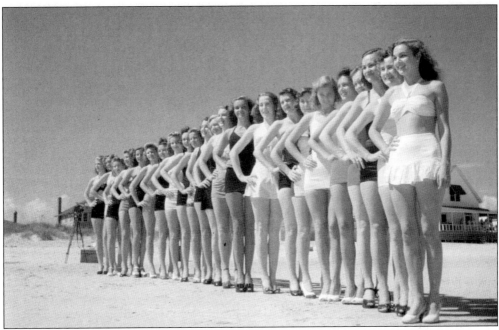

SUMMER, 1947. WRIGHTSVILLE BEACH, NC. The Miss North Carolina pageant contestants posed for press photographers on the beach in front of the Ocean Terrace Hotel. Although not identifiable in these images, the winner in 1947 was Miss Alice Vivian White of Fayetteville. The undisputed loser, seven years later, was the hotel and this stretch of beach, which was obliterated by Hurricane Hazel. The Blockade Runner Beach Resort Hotel was built on this site in 1964.

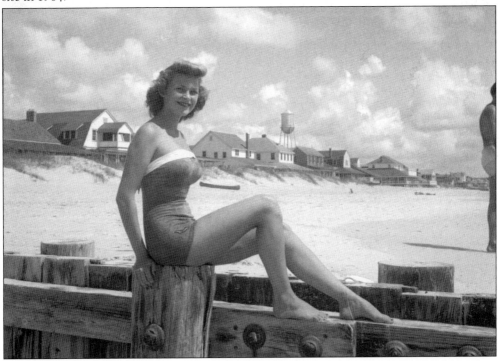

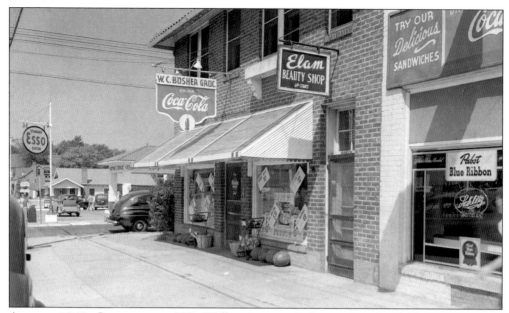

AUGUST 1948. GREENSBORO, NC. Walker Avenue, looking west toward Elam Avenue and the Esso Station (today's Wild Magnolia Café) shows a vibrant retail scene. That is still true today, although the businesses have changed. Wahoo's Tavern and Walker's Bar, and Suds and Duds Laundromat have replaced Wilbur Bosher's grocery, Elam Beauty Shop, and the Elam Drug Company. In the old days this shopping area got quiet at night, but today with the restaurants and bars, including the Blind Tiger across the street, the pace only picks up after dark.

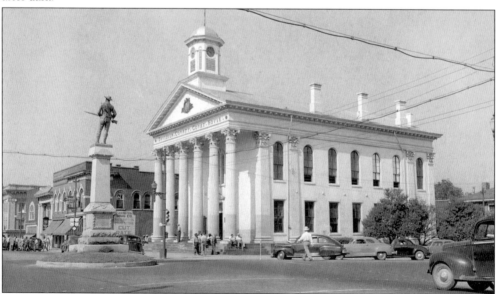

SEPTEMBER 2, 1948. THURSDAY. LEXINGTON, NC. Martin was sent to Davidson County by Burlington Industries to take a series of images of a mill village family, and he captured this view of the main square in Lexington. The old courthouse, built around 1858, was still in use as a public building at the time. It was placed on the National Register of Historic Places in 1971, and today it houses the Davidson County Historical Museum.

40

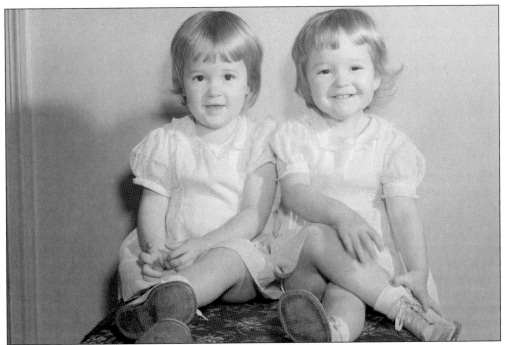

NOVEMBER 29, 1948. MONDAY, 11 A.M. GREENSBORO, NC. Martin's Studio often went into homes to take portraits, especially of young children, as they did when Linda (left) and Lorinda Foushee were photographed at 3907 Walker Avenue. Although multiple births are more frequent today—1 in 35 births for twins—it was more rare in the 1940s. The Foushee twins were part of the post World War II "baby boom" generation, which had risen to 3.6 million births per year when this image was made. It reached a peak of 4.3 million by 1957.

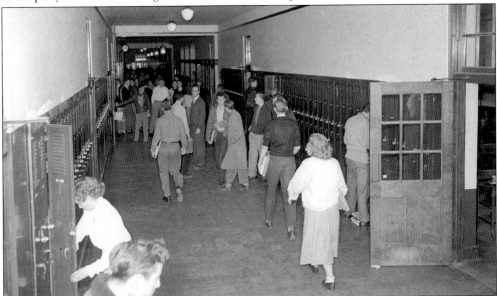

NOVEMBER 23, 1949. WEDNESDAY, GREENSBORO, NC. Although the main hall at Greensboro (Grimsley) High School has not changed a lot in over 50 years, the clothing styles certainly have.

1 pm — Mr. Spear

1:15 Pre-Natal Clinic Richardson Mem—
basement 2/36

2:00 W.B.S.G— 2/23
St Benedict School (colored)

2:30 — Carolina Grant 2/39

3:30 Mrs. Hamby (13 yr. old) # 2/22
1606 Colonial

4:30 — Mrs Ben C. Ward #2/08
Irving Park School
May day
Central Carolina Warehouse 2/40

5:00 Western Auto Show
King Cotton

MAY 19, 1948. WEDNESDAY. The studio's appointment books in the earlier years usually included the negative jacket numbers for each job of the day.

Four

WEDNESDAY,
MAY 19, 1948

WEATHER	Hi: 78 Low: 51
HEADLINES	New State of Israel Wins First Military Victory
SPORTS	Brooklyn, NY: Cardinals Beat Dodgers on Enos Slaughter's Two-run Homer Patriots Win Against Burlington Bees on Emo Showfety's 9th-inning Hit
GROCERIES	Ground Beef: 49¢ pound; Sugar: 5 pounds 45¢
SHOPPING	Nylon Hose: $1.55 at Meyers; Good Year Marathon Tire: $11.95 plus tax
MOVIES	Carolina: Robert Young & Maureen O'Hara in *Sitting Pretty* National: Dorothy Patrick & Arturo DeCordova in *New Orleans* Victory: Myrna Loy and Don Ameeche in *So Goes My Love*

With eight jobs scheduled and the earliest one not until 1 p.m., this was a compressed day. Only the first appointment was in the studio, while the remaining jobs were crowded between 1:15 and 4:30, all over town. The prenatal clinic image emphasizes the fact that Greensboro's population increased during the decade by 15,000, even though its 18-square-mile area was unchanged. The Hamby home on Colonial Avenue, photographed at 3:30, was one of 21,000 houses in the city, 40% of which were owned by the occupants. Their final three jobs of the day also reinforce some of the key business and social dynamics of the period. Business was booming, with regional sales having increased from $669 million in 1940 to over $873 million by 1950. The population was increasing at full steam, and the former ORD military base, spurred on by the aggressive marketing and development of the Bessemer Improvement Company, was a major North Carolina business and industrial incubator. By decade's end Guilford County could boast over 71,000 workers, with a total payroll of over $117 million. It was progress, and Martin's Studio was only one of the businesses beginning to prosper from the boom.

1:00 P.M. STUDIO. Mr. Samuel G. Spear was the vice-president of the Central Carolina Warehouse.

1:15 P.M. L. RICHARDSON MEMORIAL HOSPITAL. This pre-natal clinic was held in the basement of the hospital, which was Greensboro's only facility for its African-American population. In the 1940s African Americans composed about 20 percent of Guilford County's population, in a decade that saw 37,000 citizens born.

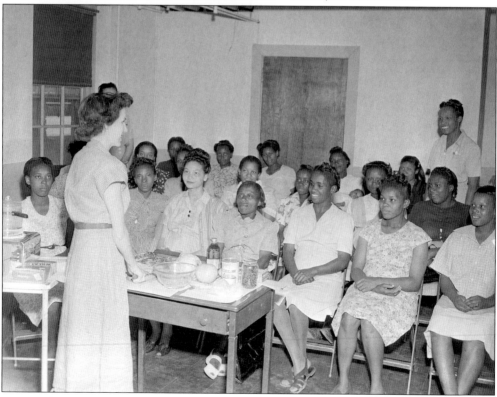

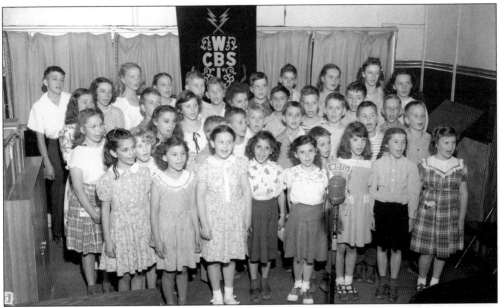

2:00 P.M. WBIG RADIO STUDIO. Students from St. Benedict Catholic School, located on North Elm Street, gave a studio broadcast performance that day. The appointment book lists this as a "colored" school, but it is likely when booking they mistook St. Benedict's for St. Mary's Catholic Mission School, which operated for African-American students at 1410 Gorrell Street.

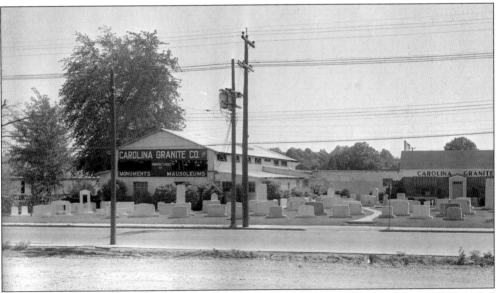

2:30 P.M. CAROLINA GRANITE COMPANY. The Carolina Granite Company on Battleground Avenue shaped Mount Airy granite into monuments, mausoleums, and a range of other products. The company was founded by Thomas Woodruff and his sons, residents of Greensboro, in 1889 when they purchased the Mount Airy quarry—today the largest open-face granite quarry in the world—for $5,000. They constructed a railroad spur off the Cape Fear and Yadkin Valley line to the foot of Flat Rock. The rest, as they say, is history, including the designation of granite as the "state rock" in 1979.

3:30 P.M. 1606 COLONIAL AVENUE. Mrs. Walter W. Hamby's twelve-year-old daughter posed formally in the family's living room.

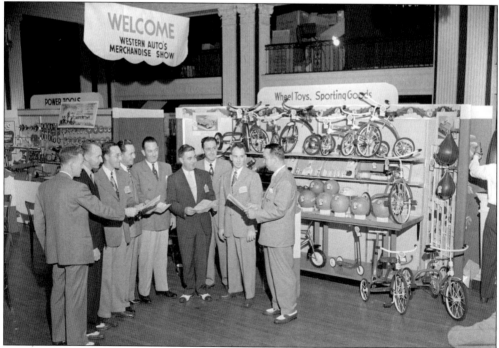

4:00 P.M. KING COTTON HOTEL BALLROOM. It was a short trip around the corner and down the street a block to photograph the Western Auto Merchandise Show. Salesmen and buyers examine the company's merchandise for the upcoming fall and Christmas season.

4:30 P.M. IRVING PARK SCHOOL, MAY DAY. This image is possibly of Mrs. Ben C. Ward's daughter. May Day pageants were very popular during these years, although not always performed on the traditional first of May. It had originated centuries before as a celebration of spring fertility or the year's first planting. In 1889, the Second Socialist International designated May Day as the holiday for the labor movement worldwide, but it is unlikely that this was on the minds of these students in Greensboro.

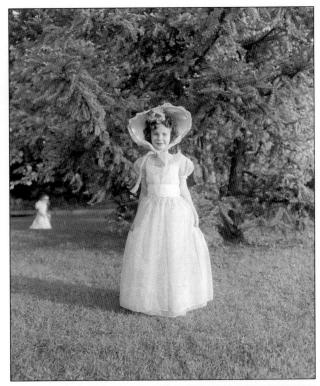

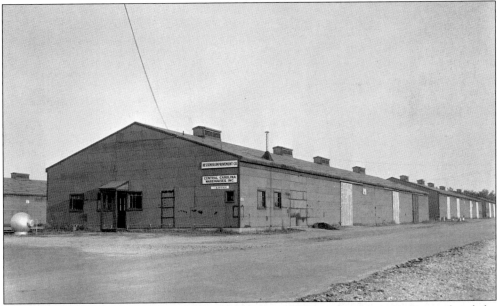

CIRCA 4:30 P.M. CENTRAL CAROLINA WAREHOUSE. When the Army Air Force closed the Overseas Replacement Depot military base in Greensboro in 1946, the Bessemer Improvement Company, whose offices are seen here, was founded and immediately bought 433 of the 650 acres of the base and half the military buildings for $200,000. In the next few years $5 million worth of warehouses, truck terminals, and officers transformed "ORD" into one of the most vibrant business areas in the state.

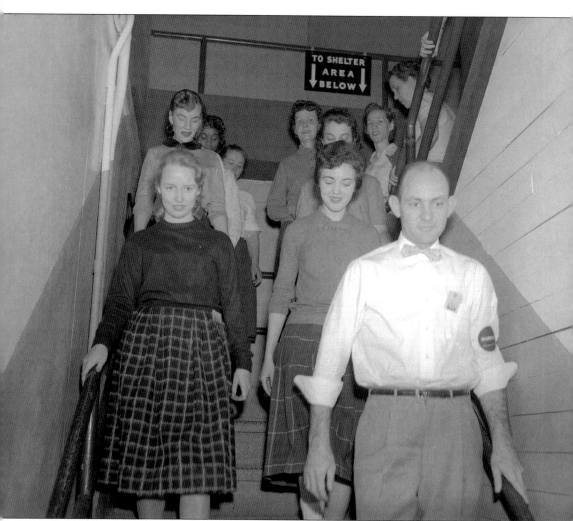

FEBRUARY 24, 1959. TUESDAY. 2 P.M. GREENSBORO, NC. The employees at the Western Electric plant on Spring Garden Street were led to the on-site bomb shelter by one of their company's civil defense wardens. With the tense international political situation between the United States and the Soviet Union at a constant simmer, this was a typical 1950s American scene. There was frequent emergency planning like this, and also lots of praying that the "cold war" would not erupt into a hot, nuclear one.

Five

THE 1950S

Some people drove quietly through the Eisenhower decade in their Studebakers listening to Pat Boone, cheering on the non-fighting, non-drinking cowboy star Hopalong Cassidy, and taking their kids for Sunday rides on the "Little Crescent" miniature railroad at Country Park. For others it was the decade of Fords and Chevys, Elvis and rock 'n roll, Billy Crash Craddock and NASCAR racing, and cruising High Point Road to the Sky Castle with your girl tucked close beside you.

The 1950s also brought Sputnik, civil defense "duck and cover" drills, labor saving dishwashers and refrigerators, interstate highways, and leisurely rides across Croatan Sound on the ferry to Manteo. It was the peak "baby boom" decade, whose growing population skewed the country's demographics and ushered in a generation consuming and recreating like never before. The number of Little League baseball teams grew from 776 to 5,700; hot dog production increased from 750 to 1,050 million pounds; potato chip production from 320 to 520 million pounds; and lawn and porch furniture from $53.6 to $145.2 million. And although education was not forgotten it became just another commodity at times, demonstrated by the $72 to $300 million increase in encyclopedia sales.

These were booming years for Greensboro too. It went from 18 to 50 square miles and its "boomer" population, helped along by a mid-decade annexation, increased from 74,389 to 119,574 citizens. This brought more of everything: automobile ownership went from 17,708 to 34,665; roads from 291 to 540 miles; and even the number of hospital beds increased from 501 to 808.

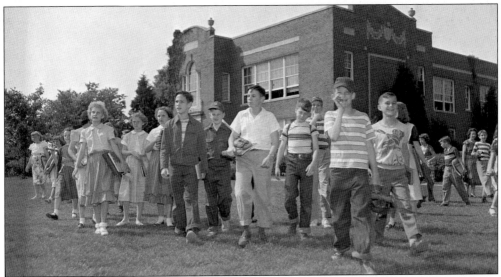

MAY 1950. GREENSBORO, NC. The end of school was in the air, although probably not quite soon enough for these kids leaving Aycock Junior High School. There were a total of 13,451 students in town in 1950, with 6 other junior highs, 3 high schools, 25 elementary schools, and 473 teachers. By 1960 there were 22,118 students, 10 junior highs, 4 high schools, 36 elementary schools, and 901 teachers.

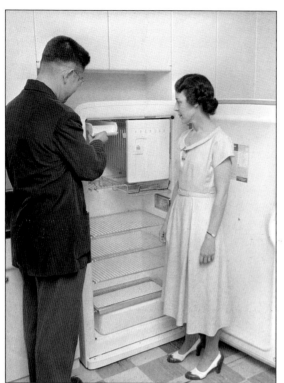

DECEMBER 19, 1950. TUESDAY. 4:30 P.M. GREENSBORO, NC. Was she dreaming of a new refrigerator for Christmas? A salesman demonstrates a state-of-the-art International Harvester refrigerator to a customer at the Baldwin-Wallace store. Similar refrigerators sold at Montgomery Ward and Meyers Department store for between $199 and $239.

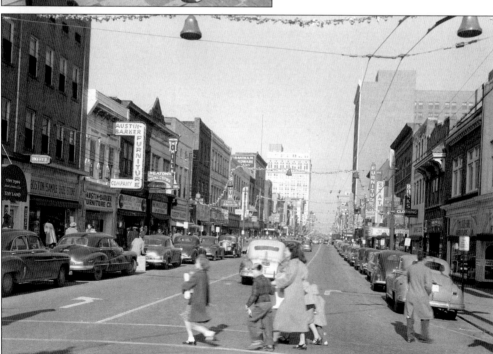

DECEMBER 1950. GREENSBORO, NC. The 300 block of South Elm Street was decked out for Christmas when this image was taken. There were some 1,500 retail and service businesses in the area then, with sales totaling close to $873 million within a 50-mile radius of Greensboro.

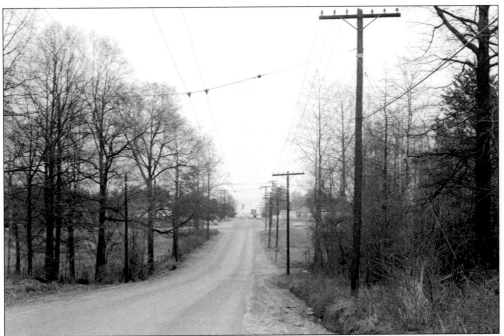

APRIL 2, 1951. MONDAY. GREENSBORO, NC. The view looking east on Spring Garden Street toward the intersection with Oakland Avenue (now Holden Road) lost its rural character long ago, especially with the opening of the Pepsi-Cola plant in 1957 and the widening of the road.

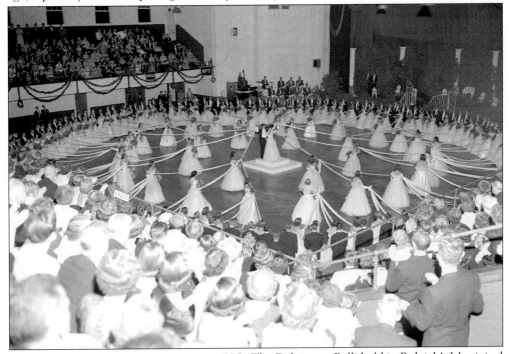

SEPTEMBER 7, 1951. FRIDAY. RALEIGH, NC. The Debutante Ball, held in Raleigh's Municipal Auditorium, celebrated its 25th anniversary that year as 148 girls made their debut. This image, along with several others, was published in the *Daily News* that Sunday.

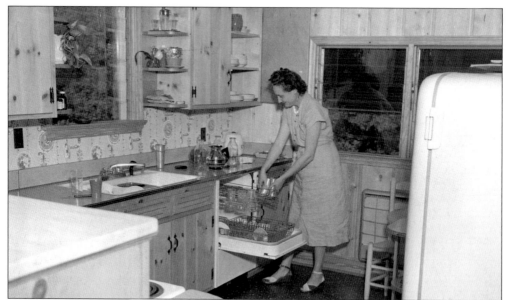

MAY 1, 1952. THURSDAY. 3 P.M. GUILFORD COLLEGE, NC. This is a good example of a modern 1950s kitchen. Electric dishwashers, like this one in the Jefferson Village house of Mrs. Rebecca Remmey, were the latest in labor saving technology, advertised as easing work and providing more leisure time for housewives.

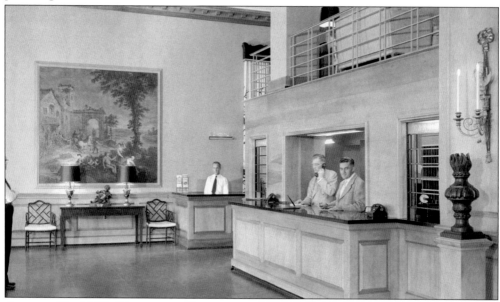

AUGUST 28, 1952. THURSDAY. CHARLOTTE, NC. The noted American interior designer Otto Zenke, of Greensboro, renovated the Barringer Hotel at 426 North Tryon Street. A student of Parson's School of Design in New York City, Zenke came to Greensboro in 1936 to work for Morrison-Neese Furniture Company and is one reason they won the 1939 Cavalier Award for the store contributing the most to the home furnishing industry in the U.S. Two years before this image he, his brother Henry, and Margaret Thompson founded Otto Zenke, Inc., and they went on to work on projects large and small throughout the world. The Barringer Hotel served customers for about 25 more years but has been used for public housing since 1983.

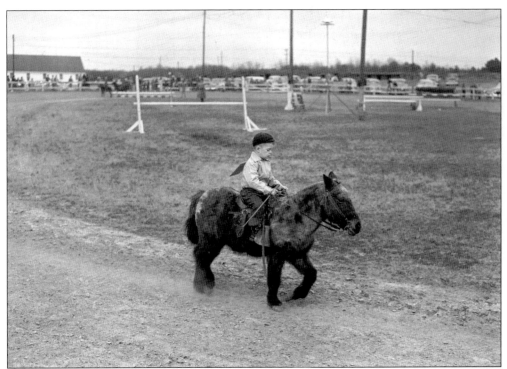

MARCH 1, 1953. SUNDAY. SEDGEFIELD, NC. This rider was most likely the youngest entry in the Sedgefield Horse Show.

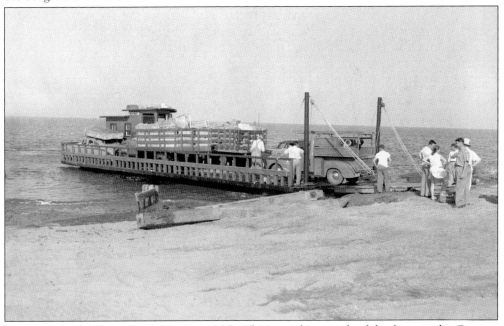

JUNE 25, 1953. THURSDAY. MANTEO, NC. This rare photograph of the ferry on the Croatan Sound at Manteo, was taken on a trip to photograph *The Lost Colony* play. Prior to the Washington Baum Bridge opening in 1956, the only way to pick up Highway 64 across the sound at Manns Harbor was via this none-too-big ferry.

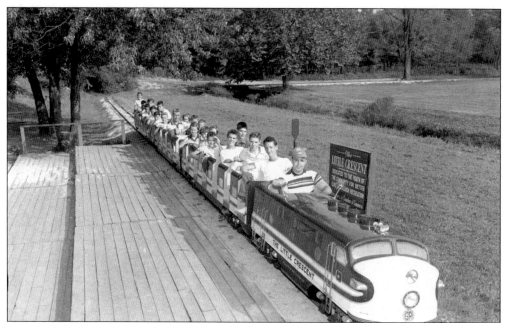

JULY 21, 1953. TUESDAY. 4:30 P.M. GREENSBORO, NC. "The Little Crescent" miniature train at Country Park was a big attraction for many years. As the sign read, it was sponsored by the Chamber of Commerce and was "Dedicated To The Youth Of The Community For Better Living Through Recreation."

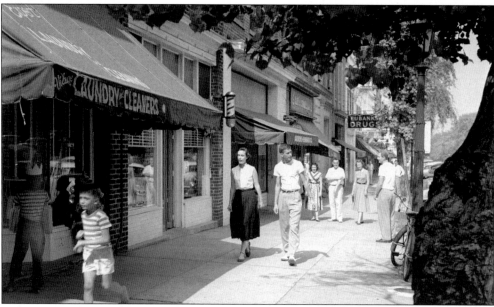

AUGUST 14, 1953. FRIDAY, 11:30 P.M. CHAPEL HILL, NC. This scene of Franklin Street was taken for the UNC *Yackety-Yack* yearbook and catches a late summer day outside Eubanks Drugstore. Although this image would suggest a rather lazy, Southern town, Chapel Hill's population surged rapidly after 1940, increasing from 3,600 people to over 9,000 by 1951. That does not include the student population either, which, with the enrollment of veterans on the G.I. Bill, reached record numbers in the late 1940s.

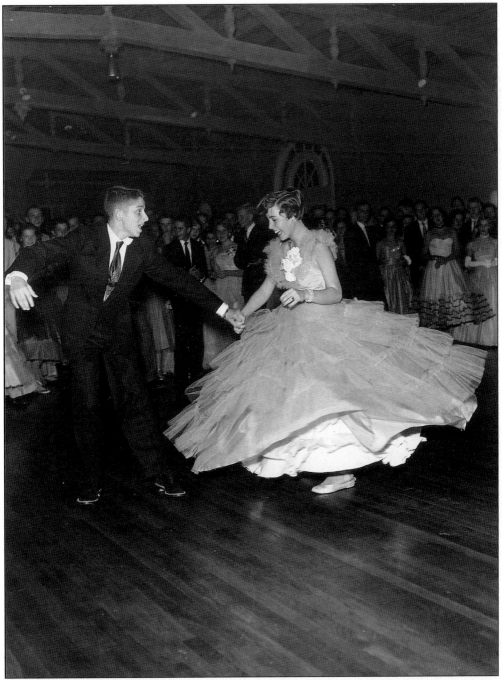

OCTOBER 24, 1953. SATURDAY. SEDGEFIELD, NC. These two unidentified Greensboro (Grimsley) High School students were the center of attention at the dance that night at the Sedgefield Manor House.

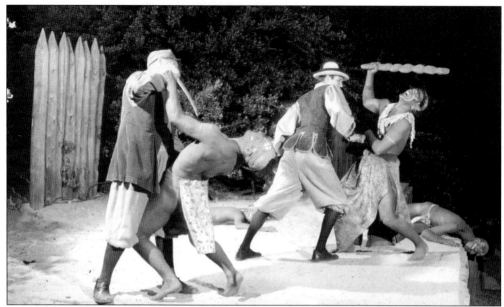

SUMMER, 1954. MANTEO, NC. This image captures the drama of *The Lost Colony*, which was in its 14th season and 654th performance. Paul Green, the noted North Carolinian and Pulitzer Prize winning writer, created a play that tells the story of the 117 men, women, and children who, in 1587, carved out the first English settlement in the new world on Roanoke Island and then disappeared into history.

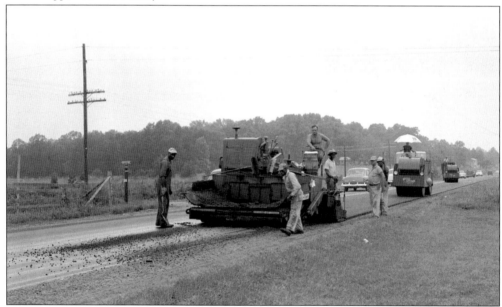

JULY 12, 1955. TUESDAY. 12 NOON. GUILFORD COUNTY, NC. The Thompson Arthur Paving Company is resurfacing an unidentified two-lane road near Greensboro. With over 305 miles of roads in the city itself, and 136 of those unpaved, there was plenty of available work, and the next year brought passage of the $50 billion Interstate Highway Act. Its projected 40,000 miles of four-lane road nationwide meant even more work for construction and paving companies like Thompson Arthur.

NOVEMBER 25, 1955. FRIDAY. GREENSBORO, NC. Western movie star Hopalong Cassidy—William "Bill" Boyd—was a big hit at the Christmas parade. "Hoppy" starred in 65 films, becoming known worldwide for a character that, by today's standards, would probably not get off the cutting room floor: a cowboy who does not smoke, drink, or kiss girls and who tries to capture bad guys instead of shooting them. "I played down the violence," he said, "and tried to make Hoppy an admirable character and insisted on grammatical English."

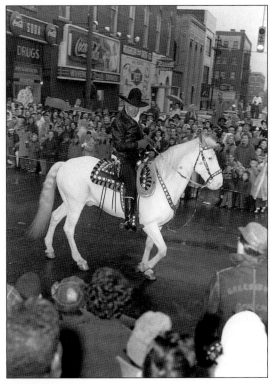

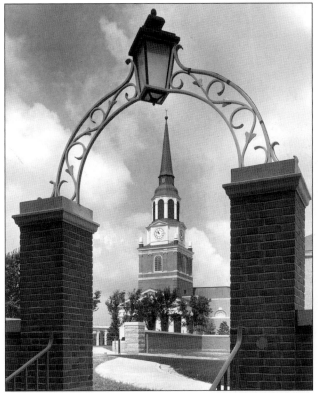

AUGUST 23, 1956. SATURDAY. WINSTON-SALEM, NC. The spire of Wait Chapel on the campus of Wake Forest College (now University) was brand new when this image was made. That was the year the college took up its new residence in Winston-Salem, after having spent the previous 122 years in the town of Wake Forest, in Wake County. This private, coeducational institution did not become a university until 1967.

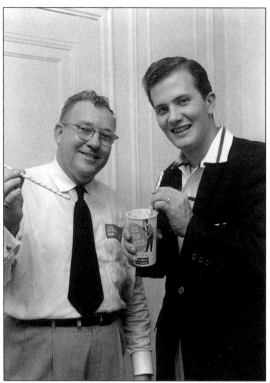

OCTOBER 5, 1956. FRIDAY. 3 P.M. GREENSBORO, NC. The singer and celebrity Pat Boone—born Charles Eugene Boone in 1934—made an advertising appearance for Southern Dairies' Sealtest Ice cream at the King Cotton Hotel. Boone was at the height of his popularity at the time, having recently achieved his second number one hit, singing Ivory Joe Hunter's *I Almost Lost My Mind.*

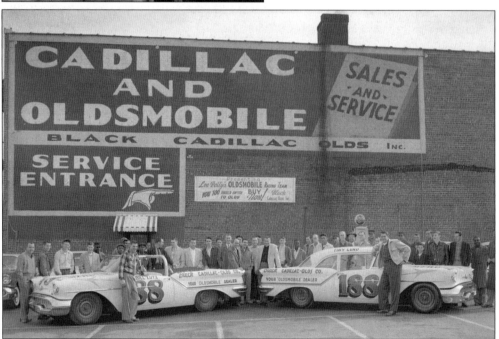

JANUARY 26, 1957. SATURDAY. 11 A.M. GREENSBORO, NC. Black Cadillac Olds, on East Market Street, sponsored the Lee Petty racing team, which included drivers DeWayne "Tiny" Lund, left, and Bill Lutz. Lund's 21-year career included victories in five NASCAR Winston-Cup races but ended tragically with his death in an accident at the Talladega 500 in 1975.

JANUARY 29, 1957. TUESDAY. 12 P.M. GREENSBORO, NC. Billy "Crash" Craddock, born in Greensboro in 1939, was appearing at the Plantation Supper Club when this portrait was made. "Knock Three Times" (1971) is the song that eventually propelled him to stardom, making Craddock the "Most Promising" male country vocal artist in 1972. Other number one singles included "Dream Lover," "Ruby Baby," and 1974's "Rub It In."

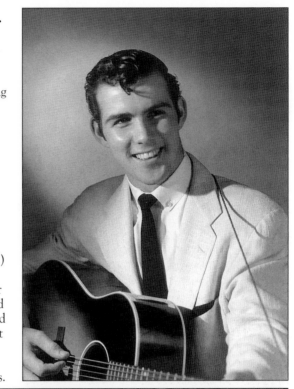

JULY 16, 1957. TUESDAY. GREENSBORO, NC. This Holiday Inn Motel on O. Henry Boulevard (U.S. 29) in east Greensboro was the first one built in North Carolina. John R. Taylor of Greensboro, a developer, builder, and community activist, built the motel, and it was open to both blacks and whites at he and his wife's insistence. Amenities included television, radio, and a telephone with "message waiting" lights.

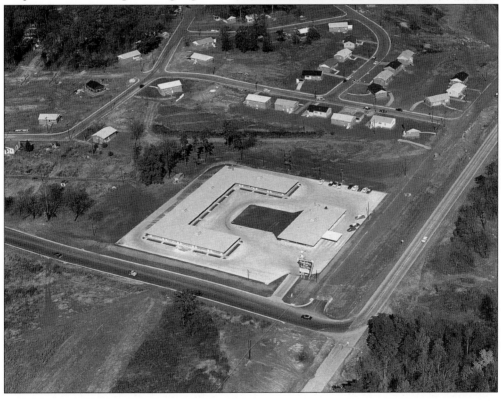

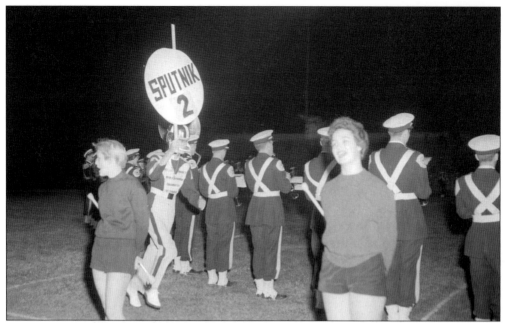

NOVEMBER 15, 1957. FRIDAY. GREENSBORO, NC. Taking a cue from the tense national headlines—which next day read "All-Out Efforts Urged in Race With Russians"—the Greensboro High School Whirlies hoped to send High Point Central's football team into a low earth orbit. Over 2,500 fans—including Sue Ellen Barker, left, and Meyressa Hughes—watched GHS do just that, in a 19-to-6 victory.

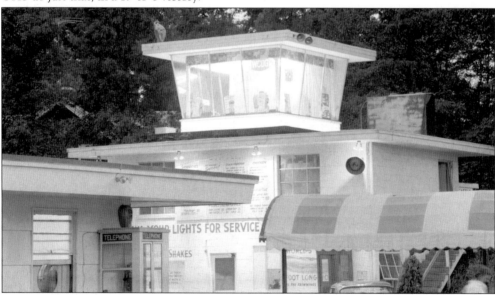

MAY 29, 1958. THURSDAY. GREENSBORO, NC. Dragging High Point Road and hanging out at the Sky Castle were teenage pastimes during the 1950s and 1960s. McClure's Restaurant originally erected the Sky Castle during the mid-1950s, with WBIG radio announcers taking requests and spinning records. To draw a younger crowd to its drive-in McClure's turned away from WBIG's more conservative play list to WCOG's rock-and-roll format, which tapped directly into the youth market.

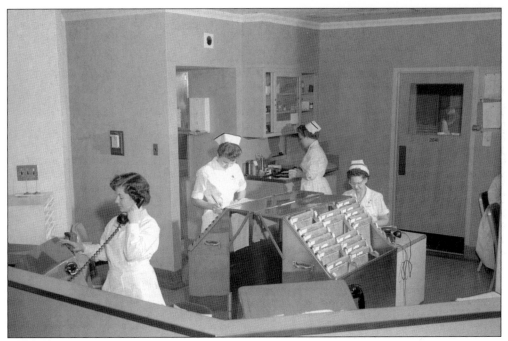

JANUARY 21, 1959. WEDNESDAY. 2 P.M. GREENSBORO, NC. The nurse's station at Moses Cone Hospital seems almost bare by today's standards. The telephone is the most visible high-tech device.

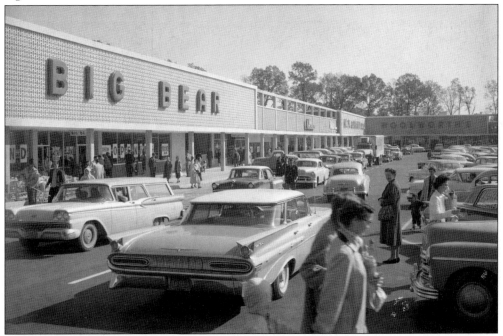

NOVEMBER 10, 1959. TUESDAY. 9:30 A.M. GREENSBORO, NC. The corner store in Northeast Shopping Center—seen here during the center's grand opening—has always housed a supermarket, with the first one being this Big Bear store. It was the second location in town, joining the store at Lawndale Shopping Center.

1953	JUNE	1953				
SUN	MON	TUE	WED	THU	FRI	SAT
	1	2	3	4	5	6
7	8	9	10	11	12	13
14	15	16	17	18	19	20
21	22	23	24	25	26	27
28	29	30				

JUNE
2
TUESDAY

1953	JULY	1953				
SUN	MON	TUE	WED	THU	FRI	SAT
			1	2	3	4
5	6	7	8	9	10	11
12	13	14	15	16	17	18
19	20	21	22	23	24	25
26	27	28	29	30	31	

	Name	Charges	Payments Rec'd
	Morning		
8.00			
8.30			
9.00	Jefferson Std.		78 77
9.30			
10.00	Mr. Parks Hunter		7975
10.30	Quaker Broom Co.	7979	
11.00			
11.30			
12.00			
	Afternoon		
12.30			
1.00			
1.30			
2.00			
2.30			
3.00			
3.30			
4.00	Mrs. W. B. Farr Jr. -home-		7966
4.30			
5.00			
5.30			
6.00			
	Evening		
6.30			
7.00			
7.30			
8.00	Hazl Campbell		7978
8.30	Prox "4"		
	TOTALS		

JUNE 2, 1953, TUESDAY. The appointment book lists the jobs for the day. The numbers are not payment information, but are the negative filing numbers.

Six

TUESDAY,
JUNE 2, 1953

WEATHER	Hi: 81 Low: 49
HEADLINES	London Packed For Queen Elizabeth II's Coronation
SPORTS	Durham Bulls Top Patriots, 6 to 5, Pats Still In First Place
GROCERIES	Ground Beef: 39¢ pound
SHOPPING	Fedders Room Air Conditioner: $229.95; Dual Grip General Tire: $11.99 plus tax
MOVIES	Carolina: Vincent Price in *House of Wax* in "3 Dimension" Center: Danny Kaye in *Hans Christian Anderson* (Admission: Matinee, Adults 60¢; Night, 74¢) Park Drive-In: *The Naughty Widow*

Although not a busy day with appointments, June 2 ended up stretching long into the night. Miller handled the early Jefferson Standard job, while Martin probably greeted Parks Hunter at 9 a.m. Hunter was the manager of Southern Bell, the only telephone option in town then. Monopoly or not, people still wanted their phones, and during the 1950s, ownership increased from 36,352 to over 69,000 units in Greensboro. There was no speed dialing, but calling was still quick since it required only four or five digits—"7237" got you Martin's Studio.

The broom photographs at 10:30 are not very exciting, but this type of work is often the bread and butter of photographic studios. As for the late-night "bowling shoot" at Proximity YMCA, we do not know who shot it, but we can say with certainty that this team would get some strange looks today if it showed up for league play on Tuesday night dressed in such attire. Bowling was one of the many 1953 amusements to choose from. More popular would have been the seven indoor or six "drive-in" theaters. There was also one legitimate theater and three auditoriums in town, as well as six area golf courses. It is always important to remember that race or class limited access to these amusements. If you were African American you would either not have been admitted or would have had to sit in a balcony or had an inferior course, court, pool, or field to play on.

If you wanted more sedate or cheap entertainment you could go down to the railroad station and watch the 22 trains arriving daily. Even more sedate? There were plenty of books in town to check out, and 50 parks with over 550 acres to read them in. Simply bored out of your mind? There were 20,492 water and 59,394 electric meters in town to watch go around!

9:00 A.M. JEFFERSON STANDARD LIFE INSURANCE COMPANY. Pictured are five employees of the Direct Mail Department, closely watched over by "Miss Allen" at right. Notice the "air conditioning" at the back of the room. Jefferson Standard (today Jefferson Pilot Financial) was a major Greensboro business, which began in Raleigh in 1907 and moved to Greensboro after merging with two local companies in 1912.

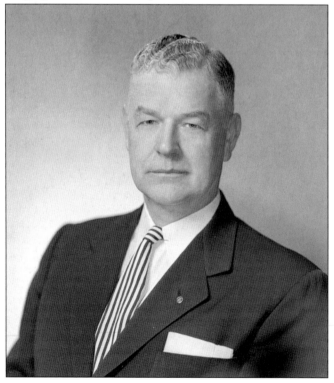

10:00 A.M. STUDIO. Mr. Parks Hunter (1905–1993), a native of Charlotte, was known in Greensboro as "Mr. Southern Bell." He transferred from Winston-Salem in 1948 and served as district manager until his retirement in 1970. His community involvement was significant. He served as president of the Greensboro Rotary Club, was a member of the Chamber of Commerce, and sat on the board of directors of the YMCA. Hunter also played a major role in organizing the United Fund, serving as its first general chairman.

10:30 A.M. QUAKER BROOM COMPANY. Most local citizens know the Lions Club through their yearly fund-raising sale of brooms. Founded in Chicago in 1917, with a Greensboro chapter established in 1922, the Lions focus their service on the blind and visually impaired. This charge resulted from Helen Keller's 1925 challenge for the Lions to become "knights of the blind in the crusade against darkness." In Greensboro, by 1934 the chapter had helped establish the Industries for the Blind, which stills provides employment for the blind and visually impaired.

4:00 P.M. 2001 MADISON AVENUE. Mrs. William Beatty Farr Jr. had Martin's Studio come to her house to photograph her two daughters, seen here and on the following page.

65

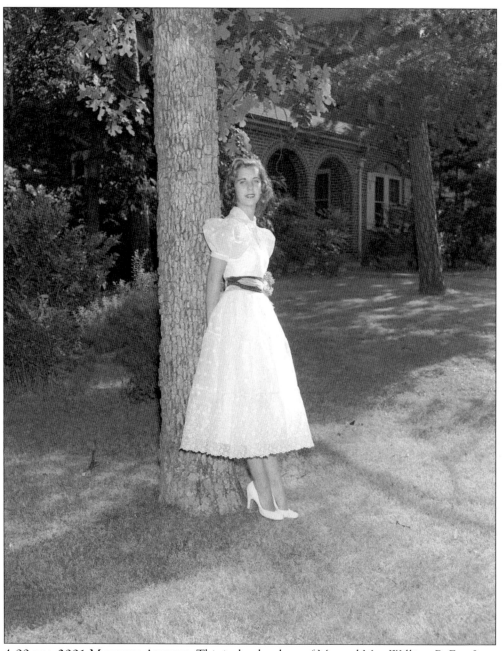

4:00 P.M. 2001 MADISON AVENUE. This is the daughter of Mr. and Mrs. William B. Farr Jr.

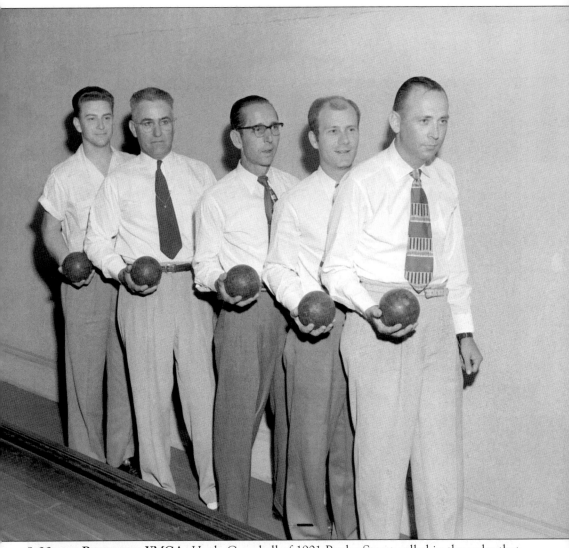

8:00 P.M. PROXIMITY YMCA. Hoyle Campbell of 1901 Poplar Street called in the order that took Martin's out to Proximity that evening. Although unidentified, they surely were the best-dressed bowlers in town.

AUGUST 17, 1960. WEDNESDAY. 8:30 P.M. GREENSBORO, NC. Vice-President Richard Nixon brought his presidential campaign to the Greensboro Coliseum, where he told over 15,000 people that "leadership" was the principal choice voters faced in the November election. He lost North Carolina to John F. Kennedy by 57,670 votes, and later claimed in his 1990 memoirs, *In The Arena*, that it was this campaign stop that cost him the election. Amid swarming crowds, he had injured his knee against a car door and within a week was hospitalized with a staph infection. His campaign was put on hold for two crucial weeks, and when he showed up for his first debate with Kennedy on September 26, he was in poor health. Nixon, along with many other political observers, felt that his poor performance that night cost him the election.

Seven
THE 1960s

The 1960s and the 1940s did not have a lot in common, but they did share one thing. Both began in peace, with the ship of state's sails unfurled rather leisurely, catching unruffled breezes everyone hoped would continue to blow. Then, all hell broke loose.

The images in this chapter do not capture much of the decade's turbulence, but the images on this page and the previous one hint at the subtext. It was a lazy summer day at Carlson Farm, and while the 1960s were six months young, it still had the feel of the laid-back, relaxing Eisenhower 1950s. In fact Ike, the calm, surefooted former general, still had six months left in the White House. His Vice President, Richard M. Nixon, came to town several weeks later hoping to convince voters that he deserved Ike's job. Bringing with him a more strident, harder political edge, Nixon was nothing like Ike. He was more representative of—in fact, in many respects he was to help define—what the confrontational, generation-divided, war-beleaguered 1960s became.

The decade indeed brought war, racial conflict, and bitterness left and right, but the photographs in this chapter reemphasize the fact that life continues. In the midst of all the national and international chaos, Miss North Carolina became Miss America; Page lost to Grimsley in football; McDonalds and Burger King strengthened their still-new fast-food popularity, but the Boar and Castle still reigned supreme out on West Market; new skyscrapers rose in Greensboro; Lowe's Hardware came to town; and Pecos Pete and John Murray were names no one would ever forget. And the city beat went on too. Street mileage zoomed from 540 to 682 miles, automobile registrations went from 34,665 to 53,000, and telephone ownership increased from 69,692 to 121,978.

JULY 8, 1960. FRIDAY. 2:30 P.M. GREENSBORO, NC. One local recreation spot was the lake at Carlson Farm west of town, which also ran a youth summer day camp.

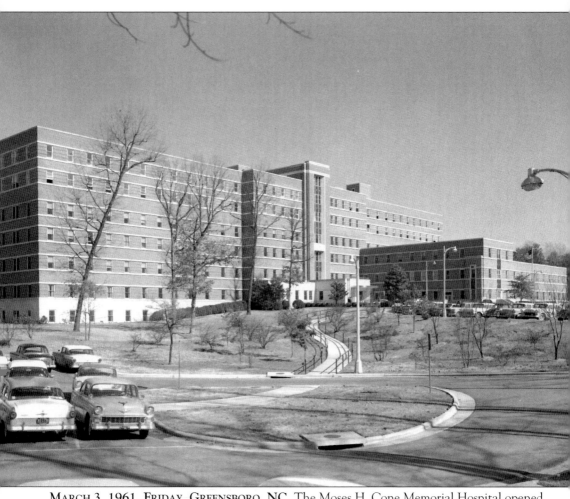

MARCH 3, 1961. FRIDAY. GREENSBORO, NC. The Moses H. Cone Memorial Hospital opened in 1953 with one operating room and 308 total beds. When this image was made eight years later Greensboro had four independent hospitals: Cone, Piedmont Memorial, Wesley Long Community, and L. Richardson Memorial, with a total of 808 beds. In the last 40 years the medical landscape in Greensboro and throughout the country has changed dramatically, with the closing and merger of many local hospitals. The only official name left standing is Moses Cone, which acquired Wesley Long Community Hospital in 1996 to form the Moses Cone Health System.

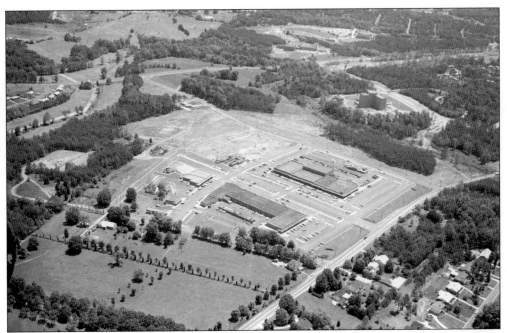

MAY 24, 1961. WEDNESDAY. GREENSBORO, NC. This aerial view looks northeast with Friendly Avenue in the foreground, the Edward Benjamin estate on the left (currently Harris Teeter and Grande Theatre location), Friendly Shopping Center in the middle, Wesley Long Hospital at upper right, and Kiser Junior High School and Greensboro High School Stadium at the top.

AUGUST 24, 1961. THURSDAY. 9 A.M. GREENSBORO, NC. When Victor M. "Vic" Nussbaum sat for Martin's he had been a resident in Greensboro for 10 years. A Harvard Business School graduate, Nussbaum was the founder and the chairman of Southern Food Service in 1954, and Southern Foods in 1960. He served on the city council for 14 years, was mayor of Greensboro from 1987 to 1993, and advised and served on numerous boards and organizations prior to his death in February 2001.

SUMMER 1961. GREENSBORO, NC. This portrait of Maria Beale Fletcher, Miss North Carolina, was taken at Woman's College for Cone Mills, who provided the fabric for this dress and other Miss North Carolina dresses during that era. Miss Fletcher, from Asheville, North Carolina and a student at Woman's College (now UNCG), went on to become Miss America of 1962, the only North Carolina woman ever to win that honor.

SEPTEMBER 28, 1961. THURSDAY. 2 P.M. GREENSBORO, NC. Workers pack York cigarettes on the production line at the Lorillard Tobacco Company plant on East Market Street. When Lorillard opened this plant in 1956, it was considered the world's most modern cigarette factory and won a *Factory Magazine* award as one of the top 10 plants of the year.

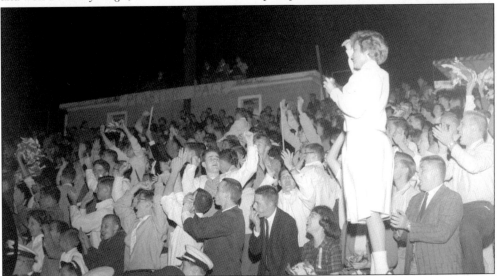

SEPTEMBER 29, 1961. FRIDAY. GREENSBORO, NC. Page High School had only been open four years and thus their rivalry with Greensboro High School was still in its infancy. The Greensboro High Whirlies were coming off a 1960 state championship and after they scored two touchdowns within 38 seconds in the first half, they cruised to a relatively easy 20-to-6 win over the Pirates.

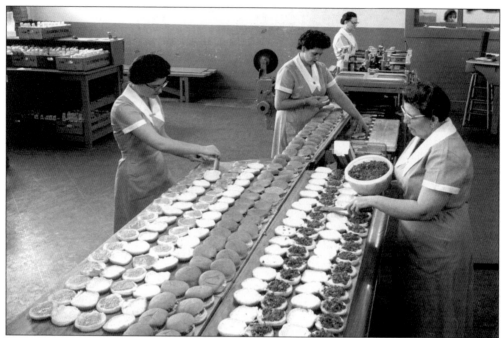

MARCH 29, 1962. THURSDAY, 1:30 P.M. GREENSBORO, NC. This is the sandwich assembly line at Made-Rite Sandwich Company, which was located at 1111 Battleground during the early 1960s. Edward and Robert McCoy created the business right after WWII, and it eventually expanded, requiring a move to the 2400 block of Battleground (beside the Golden Dragon). That plant finally closed in January of 2002.

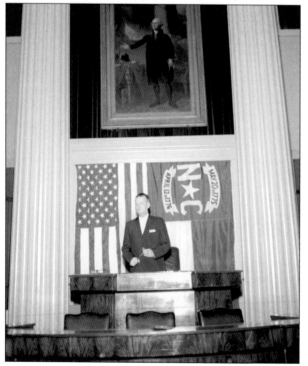

JUNE 5, 1962. THURSDAY. RALEIGH, NC. Pictured is Joseph M. Hunt Jr. of Greensboro, who was Speaker of the North Carolina General Assembly. Hunt was a native of Greensboro and vice-president of the Charles C. Wimbish Insurance Agency. He fought in the late 1950s to raise teacher salaries and became very popular locally and statewide. There had not been a speaker from Guilford County since E.J. Justice in 1907. When a reporter asked Hunt how it felt to be the speaker he replied, "I wouldn't be dead for a million dollars."

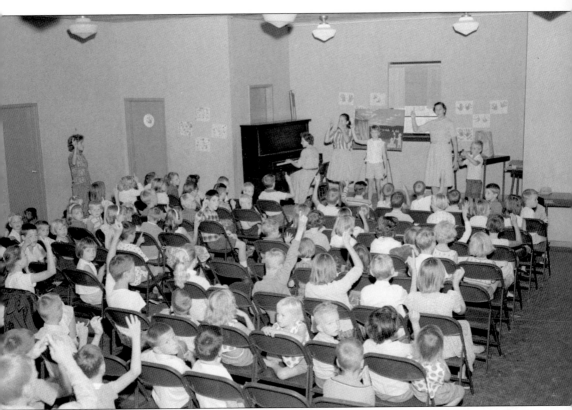

JUNE 29, 1962. FRIDAY. 9:15 A.M. GREENSBORO, NC. This bible school class in the Henry Louis Smith Homes housing project drew a large group of children. Most people today are unaware that when the publicly funded Smith Homes opened, it was a segregated white housing community. African Americans were only admitted after Dr. George Simkins—the noted local and national African-American civil rights pioneer and activist—began organizing demonstration protests in the mid-1960s.

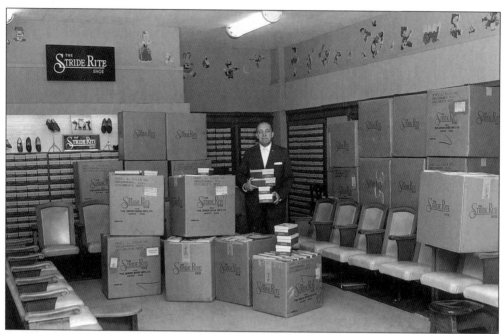

AUGUST 30, 1962. THURSDAY. 5:30 P.M. GREENSBORO, NC. In 1946 Walter Harney Sills inherited the Robert A. Sills Shoe Store on North Elm Street from his father. He kept up the tradition of excellent, personable service, with a specialization in the fitting of children's shoes. Sills was an amateur local historian, with an incredible memory and a gift for storytelling that was enthralling. He put down many of his memories in two charming volumes, *Old Times Not Forgotten*, which give a real taste of his ability to communicate history in a personal, engaging style. He once told a local reporter that he had never had writer's block. "Once I start, I can't quit." Sills died in 1999.

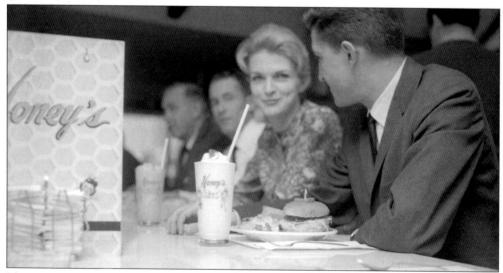

MARCH 20, 1963. WEDNESDAY. 11 A.M. GREENSBORO, NC. The Honey's Drive Inn on High Point Road (present-day Olive Garden site) was, according to the countertop glass, "A Honey of a Place to Eat." Y.L. Honey of Charlotte, who opened this location in August 1961, started the chain.

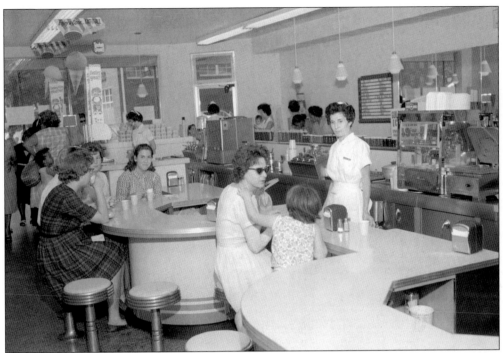

MAY 9, 1963. THURSDAY. 4 P.M. GREENSBORO, NC. Mittie Tanner, waiting on these customers at the Guilford Dairy Bar in Summit Shopping Center, was a waitress there for over 20 years. Guilford Dairy opened its first dairy bar in April 1949 next to their main plant at 3939 West Market Street. The next year they opened "Store #2" at 1616 West Lee Street and this dairy bar at 946 Summit. By the late 1950s there were five other ice cream stores in operation.

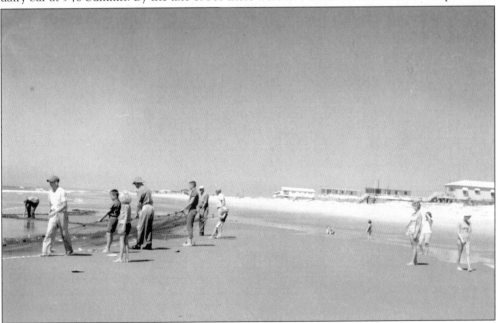

AUGUST 1963. OCEAN ISLE, NC. Ocean Isle, which is located in south Brunswick County, was incorporated as a town in 1959.

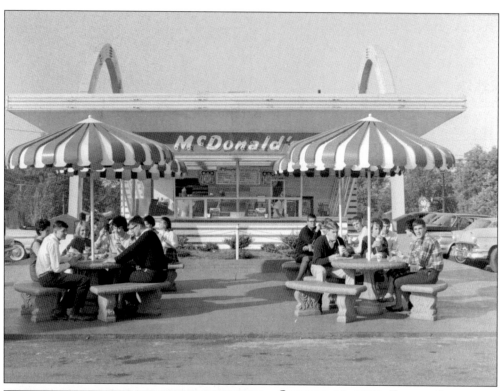

OCTOBER 11, 1963. FRIDAY. 2 P.M. GREENSBORO, NC. Only a few blocks away from Greensboro (Grimsley) High School, this McDonalds on Northwood Street was a popular student lunch-time eatery, whether they had permission to leave campus or not. It opened about a year before this image was made, was torn down in 1999, and was replaced by an Eckerd drugstore.

NOVEMBER 20, 1963. WEDNESDAY. 10 A.M. GREENSBORO, NC. Sheldon Morgenstern was a horn player with the Atlanta Symphony when he came to Greensboro in the early 1960s. He became the conductor of the Greensboro Symphony Orchestra, and the year before this image was made, he helped transform the Guilford Musical Arts Camp at Guilford College into the Eastern Music Festival, which still brings students and world-class musicians to Greensboro. After 36 years he stepped down as music and education director of the festival in November 1997.

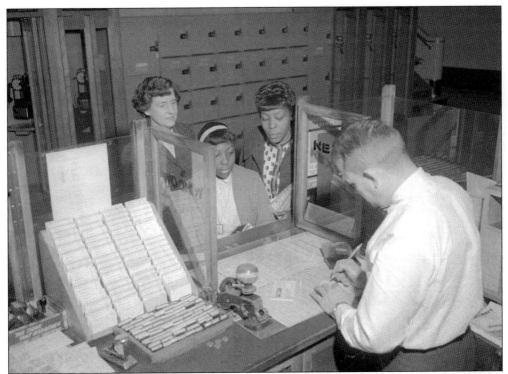

FEBRUARY 4, 1964. TUESDAY. GREENSBORO, NC. Pictured here at the bus station is 12-year-old Phyllis Oliver, daughter of Mrs. Mary N. Oliver. She received assistance from the Greensboro Heart Association to pay for a trip to the National Children's Cardiac Hospital in Miami to help her recovery from a heart condition brought on by rheumatic fever.

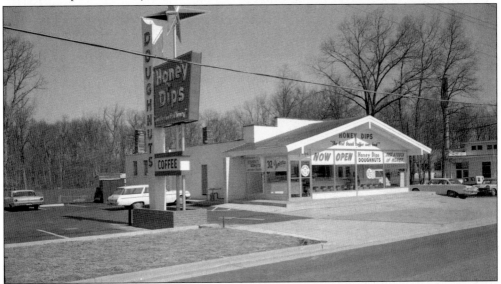

FEBRUARY 17, 1964. MONDAY. GREENSBORO, NC. The Honey Dips Doughnut store was located at the intersection of Walker Avenue and West Market. In the old days one would have only had to say "it's across from the Boar and Castle" (next page), or "beside the Canada Dry bottling company," but these landmarks, too, are no longer standing.

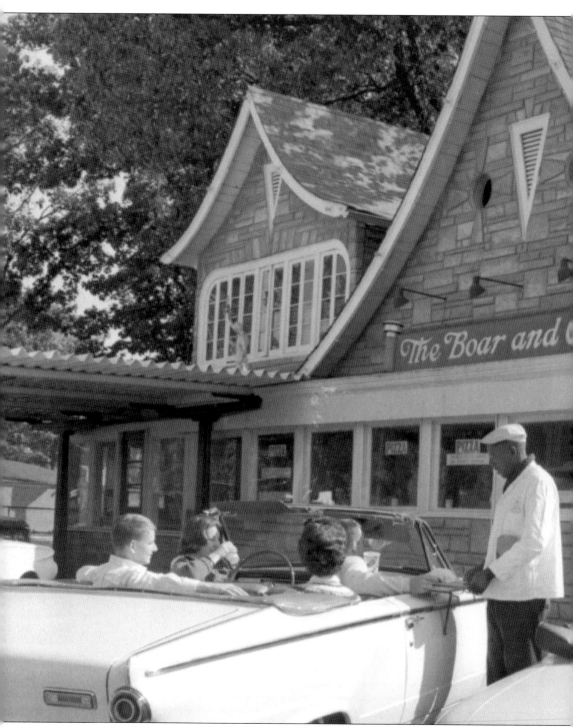

October 23, 1964. Friday. 1:30 p.m. Greensboro, NC. The Boar and Castle was a legendary 20th-century drive-in restaurant. It opened on West Market Street in 1937 and became a popular eating and cruising establishment for students, teenagers, and the young at heart. It also operated an adjacent driving range from 1938 to 1942, but it was the food, the

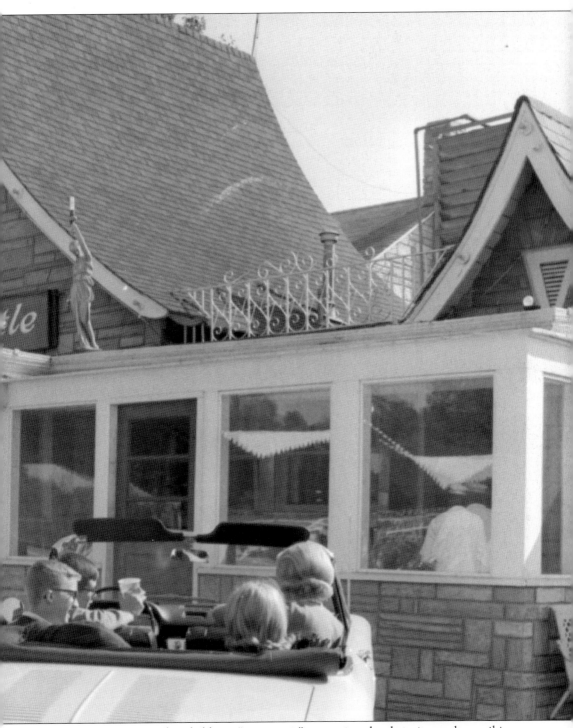

social entertainment, and probably its "passion pit" reputation that kept it popular until it was torn down in January 1981. Although the castle burgers and onion rings might be long gone, one culinary reminder—Boar & Castle Sauce—lives on at area grocery stores.

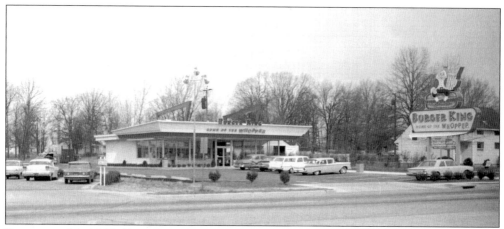

FEBRUARY 26, 1965. FRIDAY. 10:30 A.M. GREENSBORO, NC. Burger King's early "Home of the Whopper" signs were very distinctive, as seen here at the store at 1201 Summit Avenue. This store opened that month, joining the Battleground Avenue store as the second Burger King in town. Although both have been renovated many times they are still serving Whoppers at the same locations.

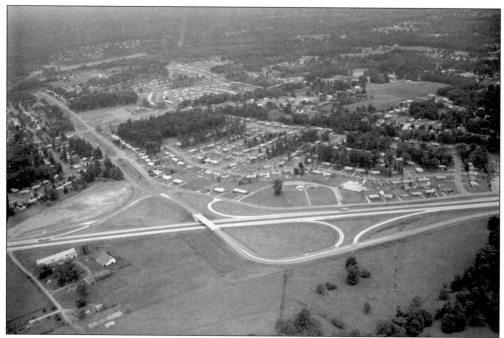

JULY 15, 1965. THURSDAY. 8:30 A.M. GREENSBORO, NC. This aerial view looks southwest across Highway 29, at its intersection with Cone Boulevard. Dr. T. Edgar Sikes, a Greensboro dentist, raised cattle on his 211-acre farm. He purchased it around 1951 from Cone Mills, which had operated their Textile Dairy on the site. About 10 years after this image was made, Sikes sold the property to developers who built Carolina Circle Mall. After struggling for much of its history, the mall finally closed in 2001, to be reborn as a retail, fitness, and sports center.

SEPTEMBER 27, 1965. MONDAY. GREENSBORO, NC. The Wachovia Bank building was under construction when Martin's shot this "white beam" ceremony. When the $4.6 million building opened, it added an economic boost and high quality office space. The opening brought huge crowds who came to see not only the building but also a million dollars on public display. This author remembers going into a vault and viewing, a bit in awe, one hundred $10,000 bills lined up in rows! Also on view were the two or more heavily armed guards beside the display.

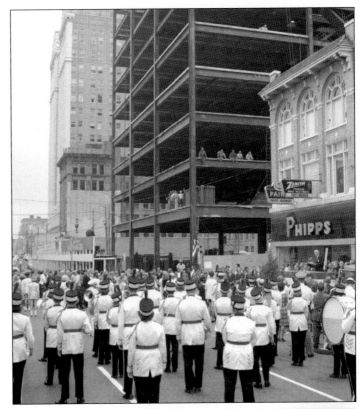

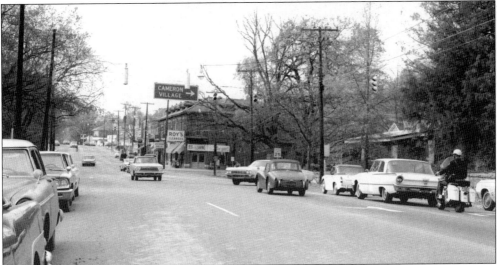

NOVEMBER 11, 1965. THURSDAY. RALEIGH, NC. This view of Hillsborough Street looks west, near Oberlin Road and the bell tower entrance to State College (NCSU). This image documented, not the street, but the directional signage to Cameron Village. When it opened in 1949 it was the first suburban shopping center in the state. Starmount Company in Greensboro—which constructed its own Friendly Shopping Center in 1957—sent Martin's to find out how easy the city of Raleigh was making it for drivers to find their way to Cameron Village.

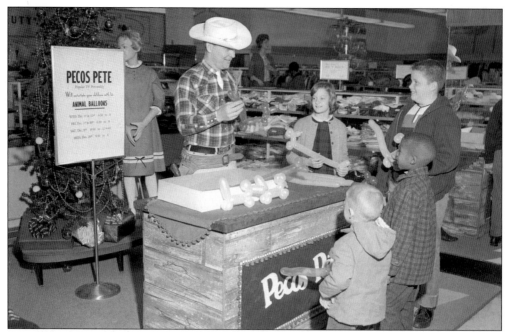

DECEMBER 11, 1965. SATURDAY. 11 A.M. GREENSBORO, NC. Pecos Pete (Jim Tucker), sidekick to the popular Old Rebel on WFMY-TV, demonstrates the art of making animal balloons at Belk's Department Store. Children all over the Piedmont looked forward to the chance to appear on their television show. Its slapstick humor, cartoons, skits, and celebrity appearances were broadcast from 1952 until 1976.

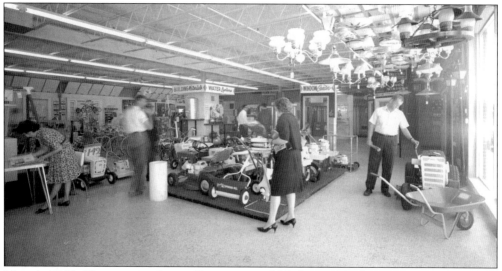

MAY 4, 1966. WEDNESDAY. 3 P.M. GREENSBORO, NC. Lowe's Hardware came to Greensboro around 1964 when it opened a store at 524 Ashe Street. In the mid-1960s they expanded to a bigger store on Patterson Avenue, as seen in this image. The Lowe's chain originated as "Mr. I.S. Lowe's North Wilkesboro Hardware" in 1921, and it began to grow in the 1950s after Lowe's son-in-law, Carl Buchan, bought out the Lowe's but decided to stick with the name. Sticking with Lowe's was a good idea for any investor. If you purchased stock in 1961 when it was first offered, by 2002, 100 shares had split into 48,000.

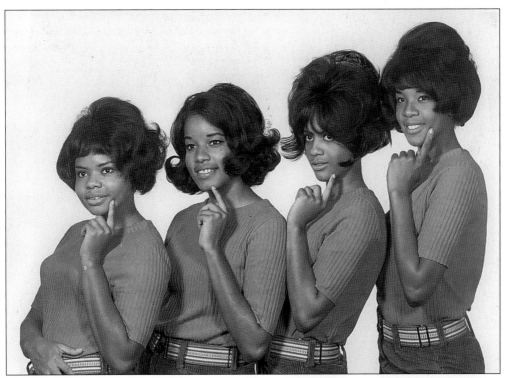

JULY 29, 1966. FRIDAY. GREENSBORO, NC. The Daydreams were composed of four freshmen from Bennett College. From left to right, Doris Smith from Henderson, North Carolina, Gwendolyn Jones from Arkansas, Brenda Johnson, from Frogmore, South Carolina, and Elizabeth Davis from Hamlet, North Carolina were discovered by local record promoter Jimmy Cheek at a college talent show. They went on to record such popular hits as "Part of Your Love" and "The Loving Side of You," on the Dial and Musicor labels. During their careers they fronted singers like Curtis Mayfield, Chuck Berry, and the Impressions.

APRIL 4, 1967. TUESDAY. GREENSBORO, NC. John Murray was voted Rookie of the Year in the East Coast Hockey League for the 1966–1967 season. The team was only eight years old, having been purchased for $2,500 by future mayor Carson Bain and 15 other shareholders, including golfer Sam Snead, from Troy, New York. The players, mostly Canadian, made about $3,500 for the season. Tickets were $1 to $3, and season passes $90. Anyone growing up during that era well remembers these names: Butch MacKay, Ron Spong, Don Carter, Pat Kelley, and goalie Jacques Monette, to name just a few.

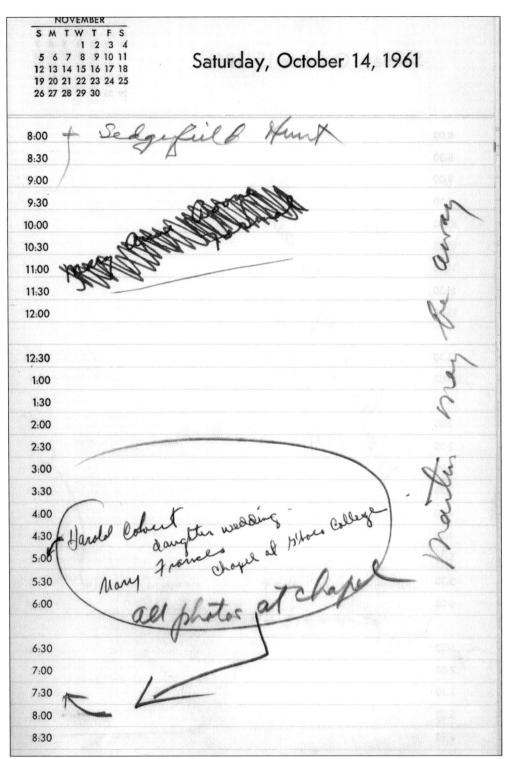

NOVEMBER

S	M	T	W	T	F	S
			1	2	3	4
5	6	7	8	9	10	11
12	13	14	15	16	17	18
19	20	21	22	23	24	25
26	27	28	29	30		

8:00 — Sedgefield Hunt

8:30

9:00

9:30

10:00

10:30

11:00

11:30

12:00

12:30

1:00

1:30

2:00

2:30

3:00

3:30

4:00

4:30 Harold Cobert daughter wedding

5:00 Frances Chapel at Gibous College

5:30 Mary

6:00 all photos at chapel

6:30

7:00

7:30

8:00

8:30

Martin may be away

OCTOBER 14, 1961. SATURDAY. The appointment books often included descriptive notes and information.

Eight

SATURDAY,
OCTOBER 14, 1961

WEATHER	Hi: 70 Low: 51
HEADLINES	U.S. Command Warns Reds About Shooting at Berlin Wall
SPORTS	In Football: Carolina Upsets Terps 14-8; Duke Loses to Georgia Tech 21-0
GROCERIES	Ground Beef: 3 pounds $1.17; Bacon: 49¢ per pound at A&P
SHOPPING	Frigidaire Refrigerator, 12.5 cu. ft., auto defrost, $249.95 (Reg. $349.95) at Meyer's; Allstate Nylon Tire, $16.88 plus tax, at Sears
MOVIES	Carolina: Natalie Wood and Warren Beatty in Elia Kazan's *Splendor In The Grass* Cinema Theatre: Mel Ferrerr and Elsa Martinelli in *Blood and Roses* North Drive-In: Brigitte Bardot in *Babette Goes To War*

This was one of those "hurry up and wait" kind of days, not all that unusual for any studio. The "hurry up" part was getting up early for the seven-mile ride out to Sedgefield to take some formal hunt pictures. Since about 1920, when the millionaire New Yorker and American Tobacco Company vice-president John B. Cobb carved out a hunting preserve and estate in these rolling Carolina hills—naming it Sedgefield, after the abundant golden sedge broom in the fields—hunting and Sedgefield went hand-in-hand. The Southern Real Estate Company purchased the Cobb property and started developing it around 1924, building a golf course—originally named Valley Brook—and the Sedgefield Inn resort hotel. It opened in 1927, which was the first year of the Sedgefield Hunt. Thankfully, being a horseman was not required to take good photographs, since neither Martin nor Miller "rode to the hounds." Although Martin was an avid outdoorsman, his preferences ran more toward fishing poles than stirrups.

Back from Sedgefield, the wait was on until 5:00 when all the gear had to be packed up for the short trip to Finch Chapel at Greensboro College. The Colvert-Lack wedding is an example of the rigorous nature of wedding photography, which is never a one-shot job. Like the hundreds of weddings they shot over the years, the entire photo event at Greensboro College lasted close to four hours. Tiring as the hours are, photographers usually get pulled from several directions—the bride's, the parents', the wedding director's—all while being expected to keep a smiles on their faces, as they encourage everyone else to do the same. Understandably, wedding photography takes a lot of stamina and is more of a young photographer's game. Yet Martin and Miller continued to shoot weddings until the mid-1980s.

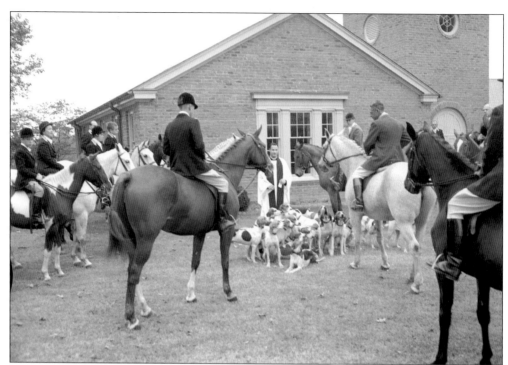

8 A.M. SEDGEFIELD, NC. The "Blessing of the Hounds" got the Sedgefield Hunt off to its early morning start. There is great tradition involved in fox hunting, especially in regards to clothing and rules of procedure, like not passing a leading rider dressed in a red coat. It is also true that not all riders are necessarily experts. Less experienced "hilltoppers" enjoy watching the action from the back, often riding around instead of over barriers, before catching up with the pack.

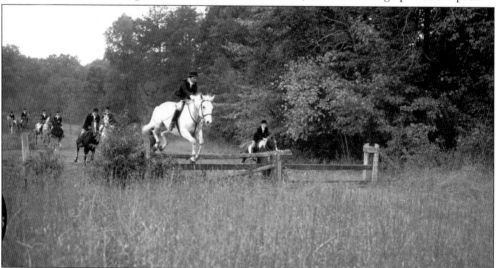

SOMETIME AFTER 8 A.M. SEDGEFIELD, NC. Although the object of the hunt that morning was one or more fox, it was and is rare for one to actually be caught and killed. Most participants then, and today, are there more for the invigorating ride—hurdling bushes and fences, splashing through creeks and ponds in the cool, crisp morning air—than they are to see the hounds corner and kill a fox.

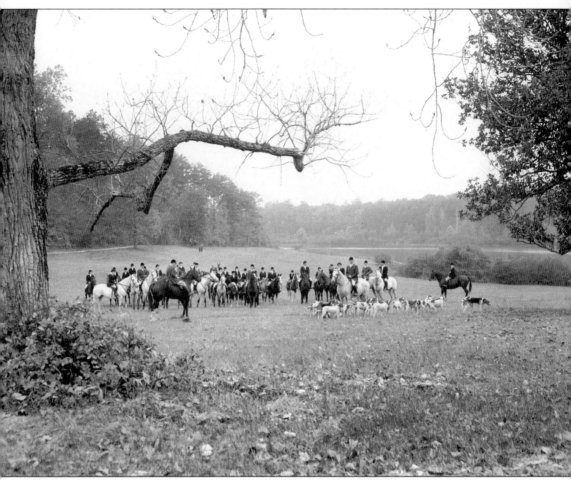

SOMETIME AFTER 8 A.M. SEDGEFIELD, NC. In the early days the Hunt began at Sedgefield Stables where the hounds were kept, and passed the entrance to the Inn, out into the 3,600 acres of fields and woods beyond. More recently, Sedgefield Hunt was forced to move to Summerfield in western Guilford County because of the lack of undeveloped land on which to ride. Forestland in the county is being lost at a rate of about 3 percent a year, or more than 25,000 acres in the last 20 years.

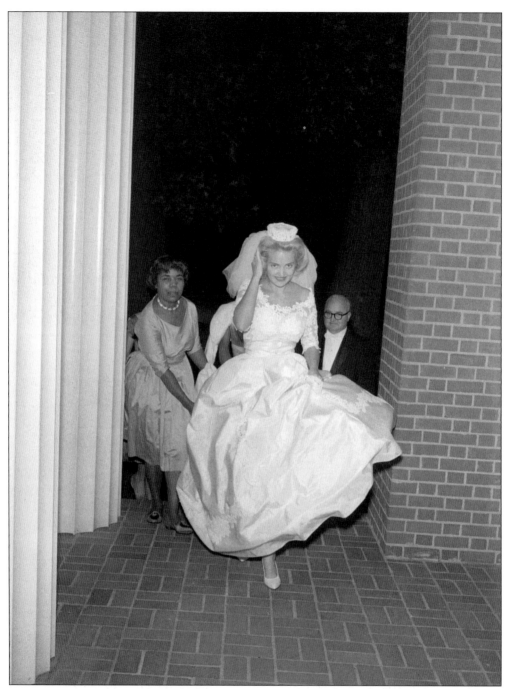

5 P.M. HANNAH BROWN FINCH MEMORIAL CHAPEL, GREENSBORO COLLEGE. Miss Mary
Frances Colvert, daughter of Mr. and Mrs. John H. Colvert of Sedgefield and a graduate in
art from Greensboro College, arrived at the chapel around 5 p.m. to finish preparations for her
8 p.m. wedding to Karl Heinz Lack. She met her future husband, a native of Frankfurt,
Germany, while teaching for the U.S. Air Force in Bermuda, where he was a hotel trainee.

8 P.M. GREENSBORO COLLEGE. Although wedding photographs are usually more interesting and valuable to the parties involved, they can actually prove valuable and interesting to local architectural and social historians. Interior and exterior views of the church or chapel often reveal interesting or useful historical details, and information about clothing and wedding rituals are also revealed.

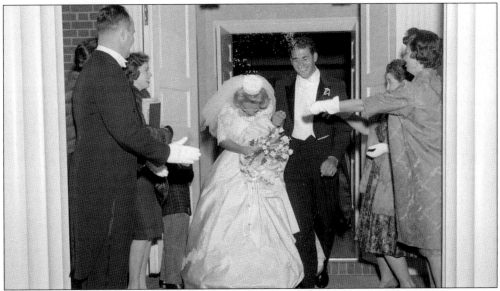

8:30 P.M. GREENSBORO COLLEGE. The newspaper's description the next day of the bride's attire was very detailed. She wore "a dress of ivory silk taffeta and Alencon lace. The lace bodice had a low oval neckline, elbow-length sleeves and pleated midriff above a natural waistline. The skirt, which had back fullness, was accented with motifs of the lace and extended into a cathedral train. She wore a bouffant illusion veil gathered to a white pillbox trimmed with lace and carried a bouquet of stephanotis about a white orchid."

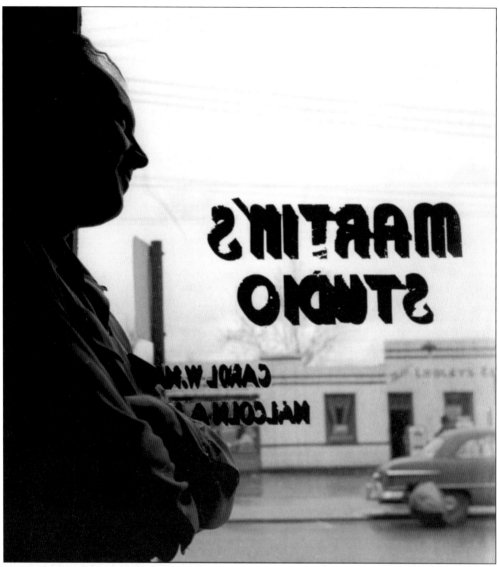

CIRCA 1950. GREENSBORO, NC. Martin's Studio overlooked downtown streets throughout its history. Here, Clarence Tucker looks out the studio window on to East Gaston Street, now Friendly Avenue.

Nine
A WINDOW ON GREENSBORO
1940 AND 1989

Sometime in early 1940 Carol Martin, still a relative newcomer to Greensboro, said he got the urge "to get up high and look around." He told Doris Dale Paysour, in a July 1982 News & Record *article, that it was just "second nature" when he set out for the roof of the Jefferson Standard Building to "take a camera, a box of holders and the old 4x5 film." When he got up there the urge to capture the view on film was overwhelming. He ended up taking 12 photographs, a 360-degree panoramic view of the city.*

What drove Martin up to the same spot almost 50 years later was probably the fact that in 1988 Jefferson-Pilot had begun construction of a second building, attached to its west side. Its design called for a tower standing far above the older building, meaning that upon its completion in 1990, Martin's 1940 vantage point would be lost forever. When that realization hit home, it is likely that his 78-year-old legs moved faster than they had in years.

The view showed some continuity but lots of changes. The change not visible was in a half-century of statistics. The city's population of 59,319 had grown to 183,521, and its 18 square miles had mushroomed to 80. Where there had been 276 miles of streets earlier, there were 876 by 1990. In addition there were 13 more banks; 117,000 more telephones, 38 more hotels; and 60 more planes landing daily, at what was now an international airport. The big decline was in the number of trains, from 38 arriving daily in 1940 to only a couple 49 years later.

On the following pages are juxtaposed the 24 total images, with the 1940 view at top and the corresponding 1989 image below it. Although the camera and lens, and the angles and framing, were slightly different, and thus do not match up exactly, these photographs make a fascinating visual comparison of Greensboro over half a century.

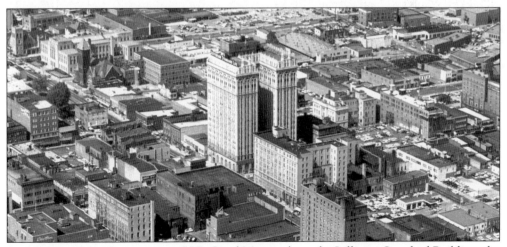

SEPTEMBER 1961. GREENSBORO, NC. Carol Martin chose the Jefferson Standard Building, the highest spot in town, to take his panoramic images.

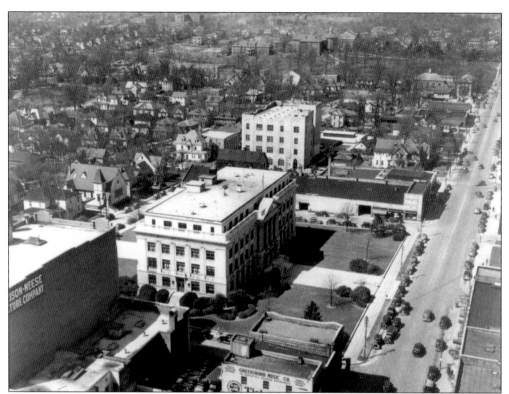

LOOKING SOUTHWEST ACROSS WEST MARKET STREET. At the top is the Guilford County Courthouse (1918), above it the four-story Southern Bell building, and above it the rotunda of Greensboro College (burned in 1941). The courthouse (below) is surrounded by new buildings: Gate City Savings (1970s), the new courthouse (1973), and additions to Southern Bell, including a communications tower.

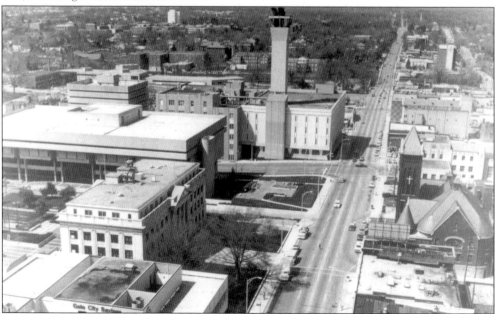

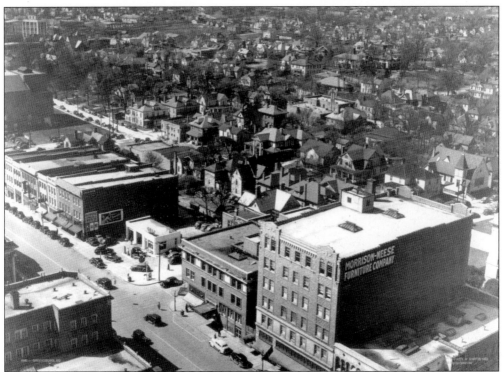

LOOKING SOUTHWEST ACROSS SOUTH GREENE STREET. The old Piedmont Hospital stood at the corner of Greene and Sycamore (beside the Morrison-Neese building). At the extreme right is the corner of the courthouse. A half-century brought significant change, with the Melvin Municipal Office Building (1973), new courthouse, and the Spring Street/Freeman Mill Road and bridge, which all displaced a large area of urban housing.

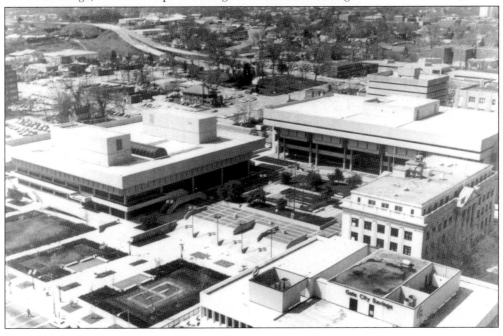

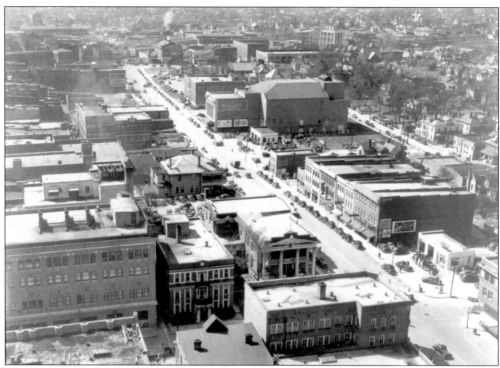

LOOKING SOUTH ON SOUTH GREENE STREET. The Carolina Theatre (1927; restored in 1977) dominates at the top. The Elks Club (columns), Reaves Infirmary, and part of Meyers Department Store run along Sycamore Street at the lower left. Note all of the gas stations. Changes by 1989 included the parking deck at center (1972), Gateway Plaza (1975) high-rise housing, and behind the Carolina, the 1955 IRS building.

LOOKING SOUTH ON SOUTH ELM STREET. The Guilford Bank Building (1925) dominates the picture above, while the older Dixie Building (1902) and, beside it, the Benbow Arcade (1904), still remained. Asheboro Street (now Martin Luther King Jr. Boulevard) is visible beyond the railroad tracks. The Dixie Building still stood in 1989, but the old Benbow had given way to Ellis, Stone Department Store. On it one can see the "HTS" lettering of the popular Wrights Clothing Store for men (closed in 1983).

LOOKING SOUTHEAST ACROSS DAVIE STREET. Partly visible at the top and under construction was the Belk's Department Store at Elm and Market. Beside Belk's was the McAdoo Building (1908), and then the Dixie Building (1902). In the distance is the 1927 Southern Railroad Station at Washington and Church. By 1989 a maze of buildings between Davie and Church had been displaced by the massive Greensboro News Company (*Daily News* and *Greensboro Record*) building.

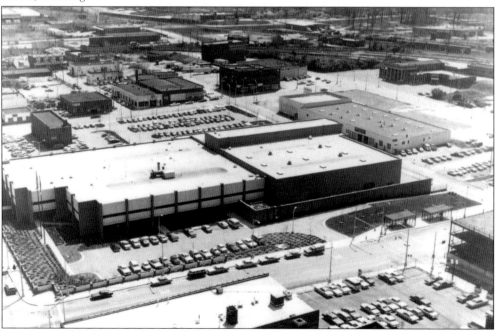

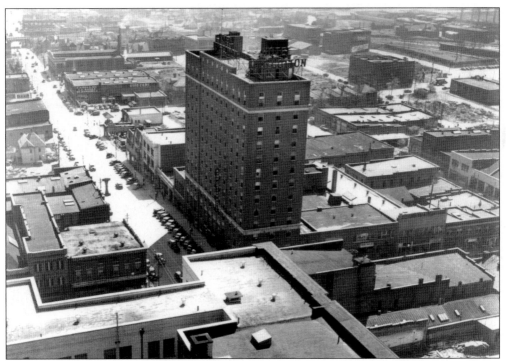

LOOKING EAST ON EAST MARKET STREET. The King Cotton Hotel (1927) at Davie and Market (top) was imploded in 1971 to make way for the Greensboro News building. The Adamson Cadillac dealership is visible at the top left, as is the railroad bridge across Market. In addition to the News building taking over the block, the big change by 1989 was the Golden Eagle Motel (1972–1990) across from the News building.

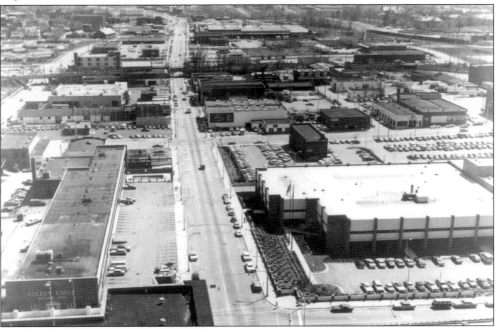

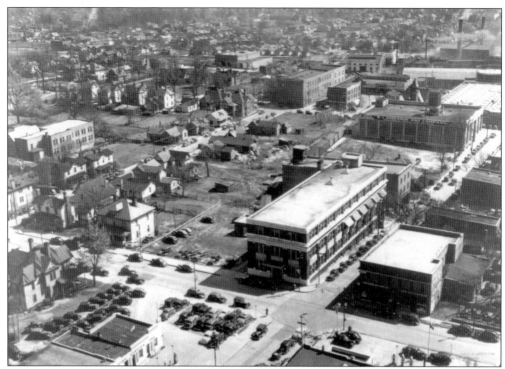

LOOKING NORTHEAST ACROSS DAVIE STREET. The old Greensboro Daily News Building (1924), dominates the top image. It was transformed into the Cultural Arts Center in 1990. The former W.L. Anderson Co. Fruits & Produce building, seen in both images, was taken over by the Imani Institute charter school in 1998. East Gaston (now Friendly Avenue) ran beside the News building, dead-ending at Duke Power's gasification storage plant (top image, right) until the road was extended in the 1960s.

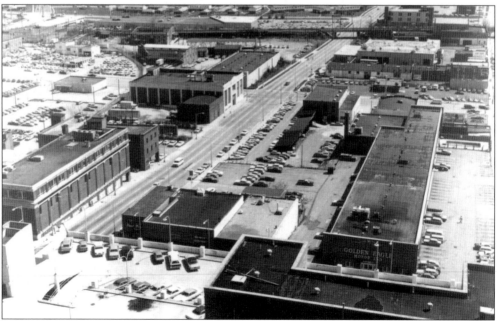

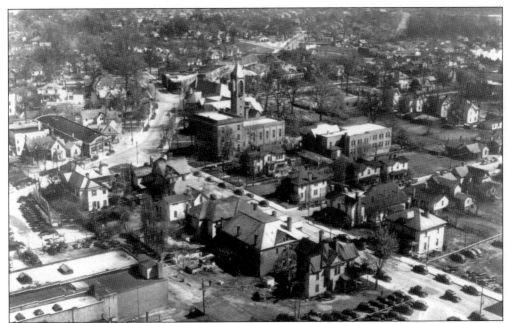

Looking Northeast across Summit Avenue. The bell tower (top) was part of the former First Presbyterian Church (moved to Fisher Park in 1928), which, in 1940, was the Richardson Civic Center, site of the Public Library, the Greensboro Historical Museum, and other civic organizations. The large building in front of the tower is the original YWCA building. Cone Mills plants are visible at top left. Within 50 years urban housing stock had given way to lots of parking lots.

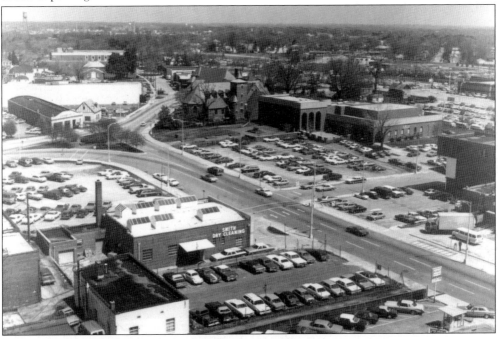

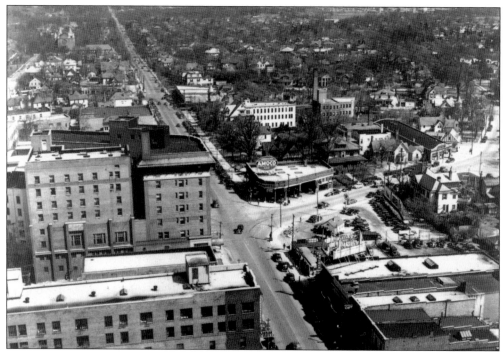

LOOKING NORTH ON NORTH ELM STREET. The original O. Henry Hotel (1919) is on the left (top), and beyond it at a distance is the massive "new" First Presbyterian Church. The white building behind the Amoco Station is the Wesley Long Hospital. By 1989 the Amoco had given way to Western Auto, and across from the Greensboro Historical Museum (the "old" First Presbyterian church) stood the Econolodge Motel (white building).

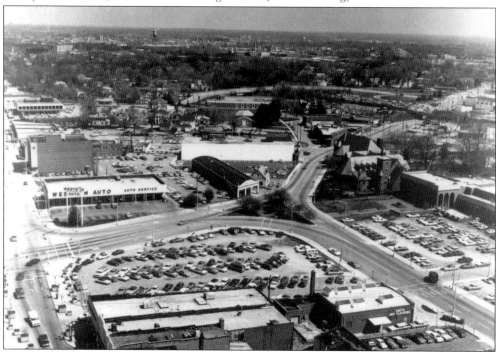

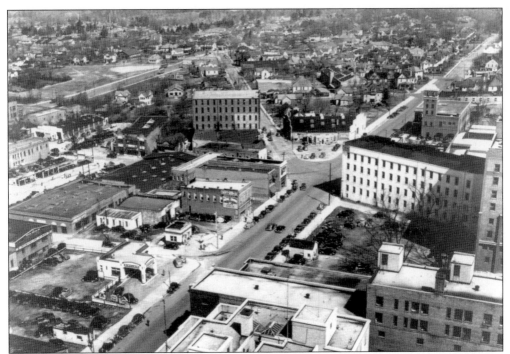

LOOKING NORTHWEST ACROSS GREENE STREET. At top, the O. Henry Hotel Annex (white building, 1919) and the Central Fire Station (1926) with its training tower are visible along Greene Street, as is the roof of old City Hall (1924). After 50 years only the fire station building still stood, although it no longer housed the department. Battleground Avenue, which angles northwest, is visible in both views.

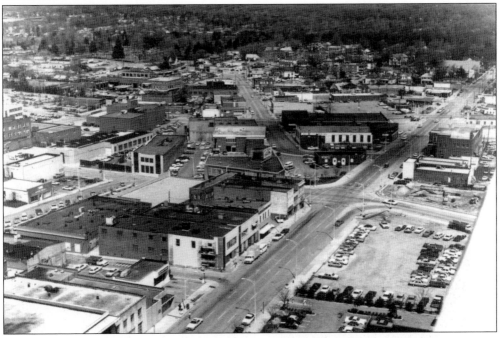

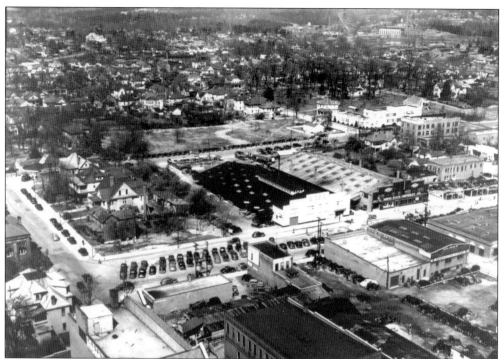

LOOKING NORTHWEST ACROSS COMMERCE STREET. At top right, the white Burlington Industries Building (1937)—now the Guilford County Social Services Building—glistens in the distance. Dominating the middle is Commerce Street, with the white-faced A&P supermarket flanked by North State Chevrolet. By 1989 North State was gone but added was the two-story Greensboro Public Library (1960), and the small tower beside it, which today is the Investors Life Insurance Co.

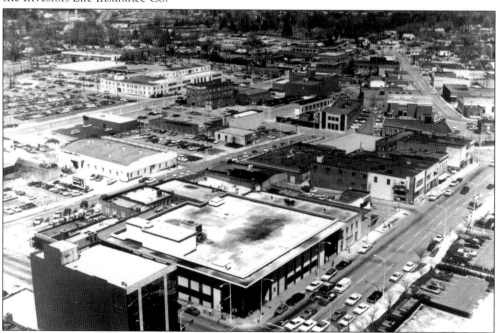

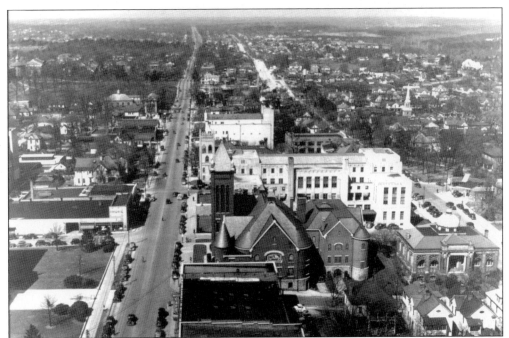

LOOKING WEST ON WEST MARKET STREET. Lining the right side of Market Street (top) which stretches into the distance, is West Market Methodist Church (1893), the 1931 Federal Building (Richardson Preyer Building today), First Baptist Church (1902), and the Masonic Temple (1928). Beside the Methodist church is the Carnegie Public Library (1906) topped by its cupola. The church's education building (1950) replaced the library. The tall white building in the distance is the Edgeworth Building (1964), today housing the Guilford County Mental Health offices.

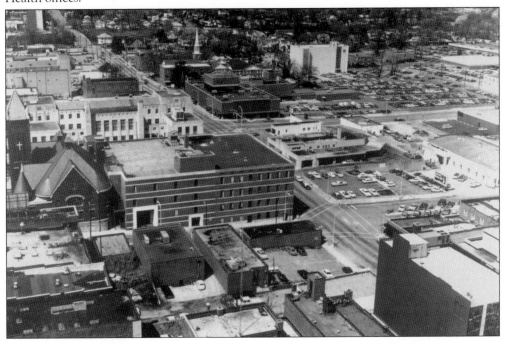

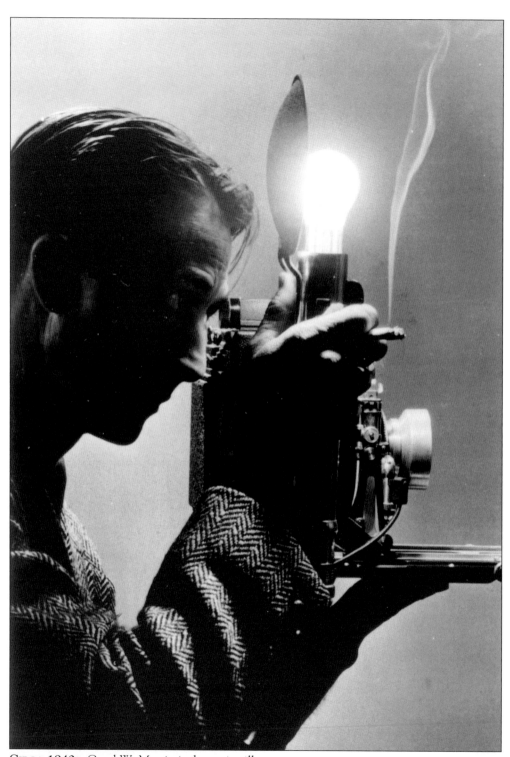

CIRCA 1940s. Carol W. Martin is shown in silhouette.

Ten
"MAYBE THE NEXT ONE"

In August 1992, two months after the studio closed, Martin was asked to pick his all-time favorite photograph. Without hesitating he told the reporter, "Maybe the next one," adding, "I'm not one who likes to go back and look at things. I like to think ahead." Indeed, he looked forward most of his career, from helping to keep the studio on the cutting-edge of techniques and equipment, to ultimately finding a permanent home for the vast photographic archive that he, Malcolm Miller, and Clarence Tucker created. In over 45 years of studio production, until the last image was made on June 17, 1992—of a Jefferson-Pilot employee—they shot over 50,000 jobs, producing well over 200,000 negatives. Although he assembled images over the years for various people and pulled a lot of interesting photographs in 1990 for use by the News & Record during its centennial year, Martin never systematically selected images from the vast archive with the eye to publishing them in his own book. That daunting, rather humbling experience has fallen to this author over the last ten years. It began on a hot, steamy July day when Carol called to say, "come get the collection." As my son and I carried away over 200 shoe boxes of negatives from the studio, I kept peeking inside at the amazing contents, hardly believing some of the images I saw.

So I have tried to find the "ones" among the thousands, which I considered to be the best, or most moving, or most meaningful to our local and regional history. Even after two books, what still amazes me is that there are so many wonderful photographs yet to be seen.

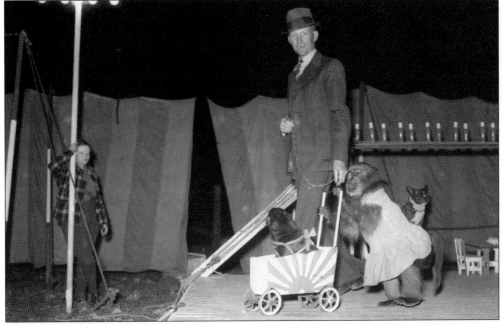

FALL 1938. GREENSBORO. This unidentified carnival act played to Greensboro audiences.

SPRING, 1939. BIG ALAMANCE CREEK, GUILFORD COUNTY. These unidentified girl scouts enjoy a nature walk at the Old Mill Camp in eastern Guilford County.

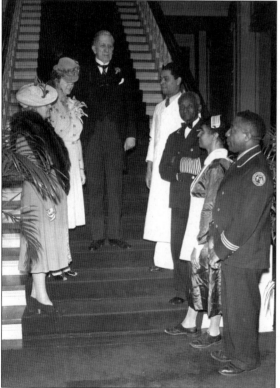

JANUARY 9, 1941. THURSDAY. RALEIGH, NC. "Hoeys Say Farewell To Mansion Servants," read the headline for this image, published the next day in the *Daily News*. The caption read, in part: "Gov. Clyde R. Hoey and members of his family bade servants at the mansion farewell yesterday before they left for Memorial auditorium to see Governor-elect J.M. Broughton inaugurated. Right to left, they are Wonder Blackledge, cook and waiter; Eva Ward, ladies' attendant; "Uncle" David Haywood, butler, who has served 12 governors, Broughton making his 13th; Len Parker, cook; Governor Hoey; his daughter, Miss Isabel Hoey, and Mrs. Hoey."

FALL 1942. GREENSBORO, NC. Mrs. Elizabeth V. Berry, wife of William V. Berry of Berry Coal Co. (today's Berico), was awarded a prestigious national honor when she was selected as the "American Mother of 1942" by the Golden Rule Foundation of New York, for her contributions to family, community, and the nation.

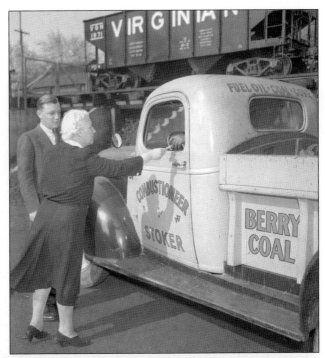

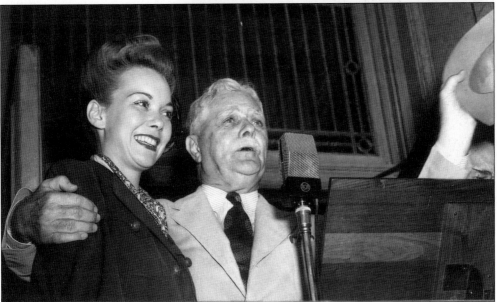

SEPTEMBER 15, 1942. TUESDAY. GREENSBORO, NC. Julian Price, president of Jefferson Standard Life Insurance Company, and state chairman of war bond sales, appeared with actress Jane Wyman on the steps of city hall during a bond rally. She—along with actor John Payne—helped sell $781,618 in bonds, which, in one day, surpassed the city's monthly goal of $700,000. This image was published the next day with a caption noting that Price's arm around Miss Wyman "was not exactly gratis, since it was bought with a considerable bond purchase." Miss Wyman, born Sarah Jane Fulks, was married at the time to actor Ronald Reagan, and had recently appeared in *My Favorite Spy* and *Footlight Serenade*.

CIRCA 1942. GREENSBORO, NC. This rare image resulted from Martin sneaking into the Guilford County Courthouse with his camera. From a window in the supply room he surreptitiously snapped this image of a trial in progress. As soon as the flash went off the wrath of the judge came down on him.

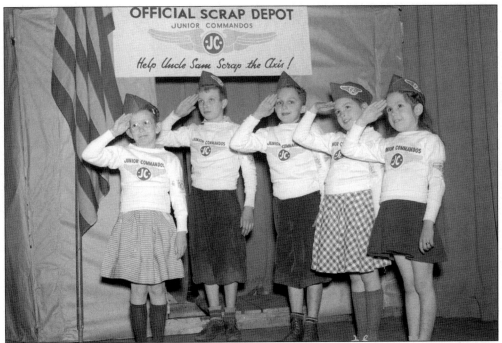

MARCH, 1943. FRIDAY. GREENSBORO, NC. "Colonel" Martha Ann Gallimore, and "Captains" Jim Fulton, George Cornwell, Patricia Booth, and Dorothy Foster, were members of the Lindley Elementary School "Junior Commandos." Lindley collected over 40,000 pounds of scrap metal during the first drive in March 1943.

AUGUST 13, 1943. GREENSBORO, NC. These three newspaper delivery boys—from left, Charles Taylor, Billy Barber, and Harold Sloan—won prizes for outstanding work in selling War Savings Stamps. The announcement in the paper noted that they were 3 of 1,600 carriers. It also went on to state that none of them were "soft and indolent youngsters." Carrying newspapers was "tough" work, so "don't let anyone kid you that it is otherwise—but these better type youngsters stick to it through sun and rain and storm while their brothers, relatives, and friends fight in Africa and the South Pacific."

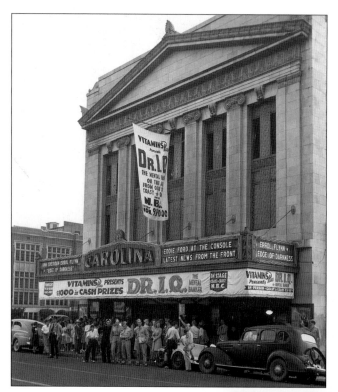

AUGUST 16, 1943. MONDAY. GREENSBORO, NC. The newspaper ad read "America Listens to Greensboro Tonight!" It was the weekly Monday night NBC radio broadcast of the popular Dr. I.Q. *The Mental Banker* quiz show. Why was it broadcast from the Carolina Theatre during the month of August? The sponsor, Vitamins Plus, was a division of Vicks Chemical Company, whose national headquarters was located in the city. Two hundred dollars worth of silver dollars were given out that night for correct answers. Among the Greensboro winners were Mrs. C.W. Cloninger, $26; Lorene Turner, $22; Dr. R.L. Underwood, $22; and L. F. Oettinger, $9.

OCTOBER 26, 1943. TUESDAY. GREENSBORO, NC. Actress Jeanette McDonald was in town to promote war bond sales when Carol Martin caught up with her in the dining room of the O. Henry Hotel. She was scheduled to appear at Aycock Auditorium the next Saturday, but crowds were already lining up at the O. Henry to gawk at the Hollywood star. The newspaper noted that she was dressed in black, wearing a green hat, with yellow feather. "That's to keep me happy," she told the reporter.

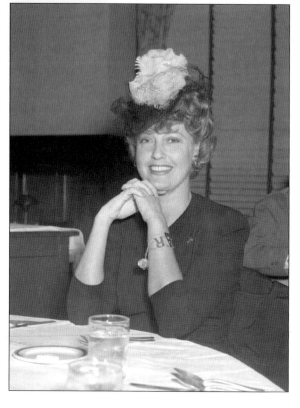

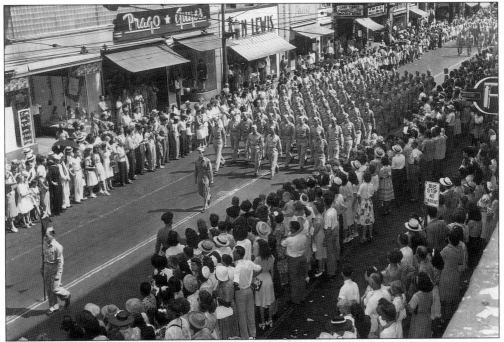

AUGUST 15, 1945. WEDNESDAY. GREENSBORO, NC. "Thousands lined Greene and Elm Streets yesterday afternoon to cheer ORD soldiers marching in parade celebrating the end of the world's most terrible war," reported the *Greensboro Daily News* on the 16th. The entire city had erupted in wild celebrations the night before, when President Harry Truman announced that the Japanese had accepted allied surrender terms and that WWII was over. The local sacrifices were significant. Of the 17,656 Guilford County men and women who served in the WWII, 609 were killed: 267 from Greensboro, 171 from High Point, and 171 from rural Guilford.

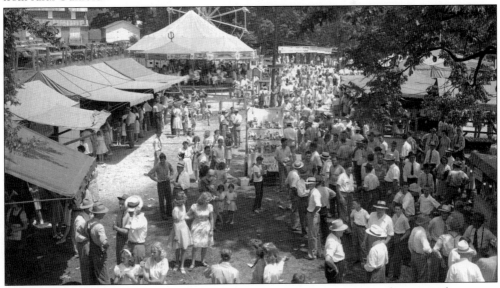

FALL, 1945. DAVIE COUNTY, NC. This image captures a county fair somewhere near Mocksville. The activities are recognizable but the formal dress is certainly from another era.

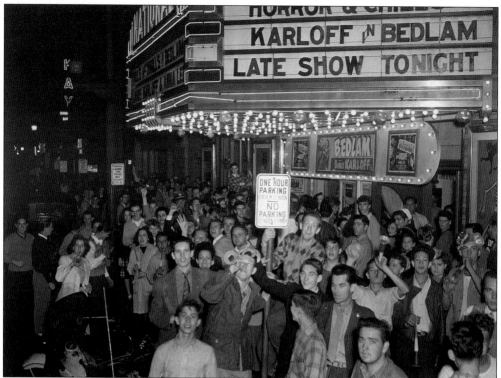

CIRCA 1946. GREENSBORO, NC. "Bedlam" may have been a good description of this crowd as well. Actually the jubilant crowd who came to see Boris Karloff in "Bedlam" was celebrating the resumption of night movies at the National Theatre. The downtown had been blacked out at night during WWII.

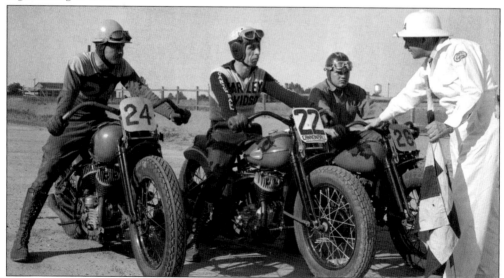

MAY 23, 1946. THURSDAY. GREENSBORO, NC. These motorcycle racers were practicing at the Greensboro Fairgrounds (current parking lot of the Greensboro Coliseum) for the American Motorcycle Association sanctioned races to be held on the 25th and 26th. It was sponsored by the Greensboro Motorcycle Club, Inc., with a top price of $1,000.

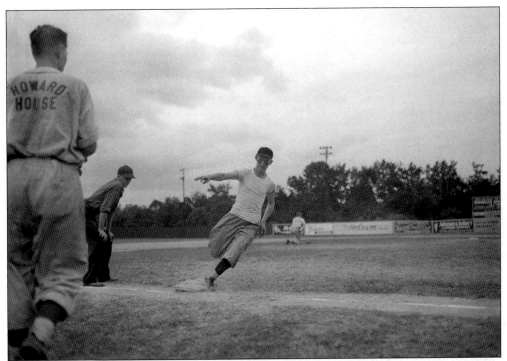

AUGUST 18, 1946. SUNDAY. GREENSBORO, NC. The state softball tournament was held in Greensboro at War Memorial Stadium that weekend. Burtner Furniture beat Henderson that afternoon and went on to win the championship on Monday night, when 1,500 spectators saw them defeat the Roanoke Romancos 2-0.

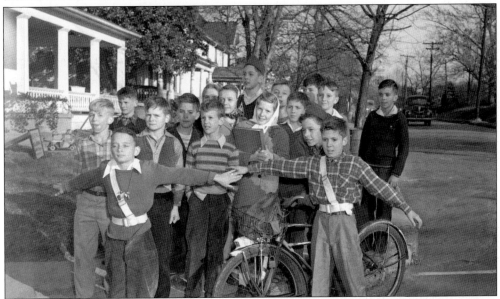

CIRCA 1946. GREENSBORO, NC. Bobby Driver, left, was one of the school patrol captains. This was a prestigious job during those years, not only because of the responsibility it entailed, but because you got to wear the belt, badges, and carry a whistle, not to mention being able to order around your peers.

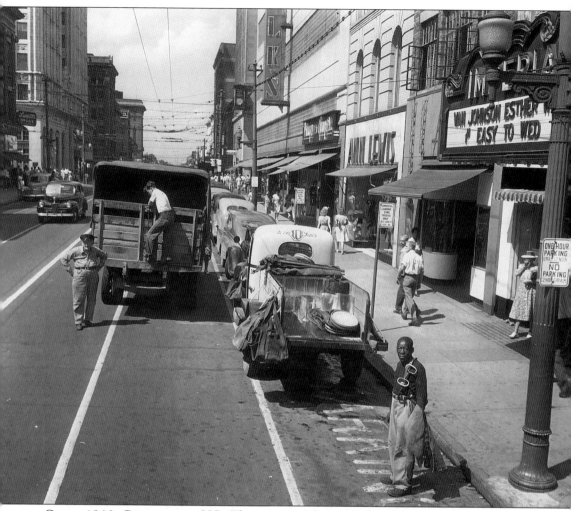

Circa 1946. Greensboro, NC. The iceman delivers blocks of ice for cold drinks to the Imperial Theatre on South Elm Street.

JUNE 24, 1948. THURSDAY. 2 P.M. GREENSBORO, NC. "O.K., you caught me! But could I still have a bottle of milk, or maybe some of that Jell-O in the big bowl? But I don't want any of Filbert's Oleo Margarine, yuck!" That, at least, is one possible caption for this image of Mrs. Thomas Stansill's baby raiding the refrigerator.

THE 1940S. GREENSBORO, NC. The legendary teacher and director Herbert Hazelman taught these Greensboro (Grimsley) Senior High School band and orchestra students. He came to GHS in 1936 and reestablished the music program, which had been suspended because of the Great Depression. His many accomplishments included composing, in 1949, the school's Alma Mater.

THE 1940s. GREENSBORO, NC. Bobo Barnett was a well-known 1940s and 1950s clown who worked with animals. He appeared on television programs, such as the Ed Sullivan Show, and brought laughter to crowds all over the world.

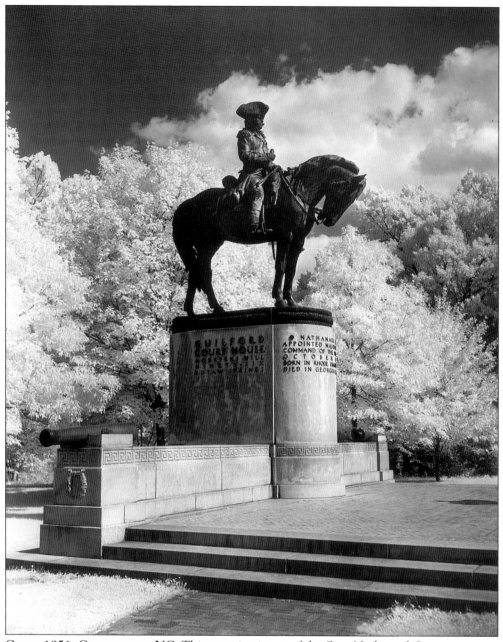

CIRCA 1951. GREENSBORO, NC. This stunning image of the Gen. Nathanael Greene statue at the Guilford Battleground National Military Park was taken with infrared film. General Greene is the Revolutionary War hero for whom Greensboro is named. The statue, dedicated in 1915, sits inside the Guilford Courthouse National Military Park.

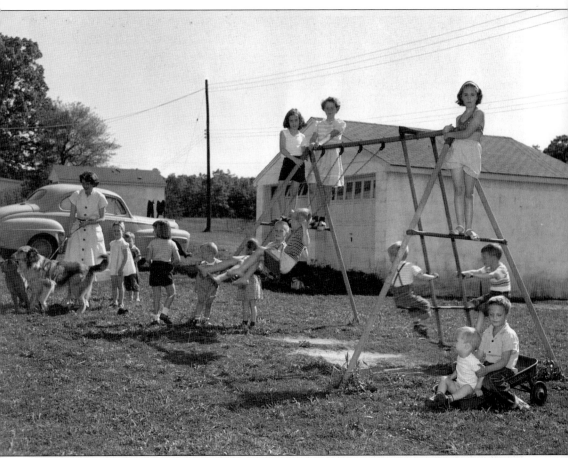

MAY 1, 1952. THURSDAY. 3P.M. GUILFORD COLLEGE, NC. There were lots of potential playmates during the baby boom years of the 1950s, as seen here in the Jefferson Village development at Guilford College. This image was made on a trip to photograph the kitchen (see page 52) of the E.M. Remmey home.

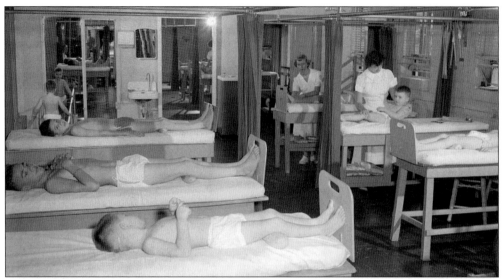

AUGUST 15, 1952. FRIDAY. GREENSBORO, NC. This was an all-too-familiar and frightening scene during the late 1940s and early 1950s in Guilford County and the nation. In fact, in 1948 the polio epidemic struck Guilford County more severely than any other area of the country. These images were doubly emotional for Martin. The only reason he was allowed to photograph inside the Central Carolina Convalescent Hospital was because one of his daughters had been stricken with the disease. He agreed to document the children and hospital, for free, if he would be allowed to visit his daughter as often as he wished.

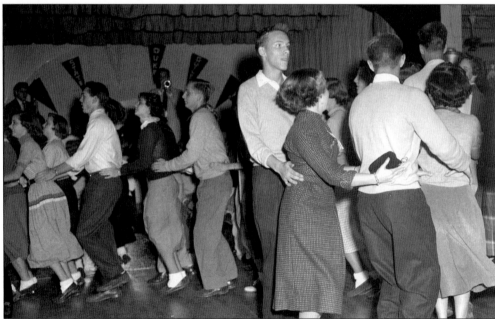

OCTOBER 2, 1953. FRIDAY. GREENSBORO, NC. The "Bunny Hop" was still a popular group dance, especially with these Greensboro (Grimsley) High School students, seen here at the Youth Center downtown. They were getting energized for the big football game that night. Along with 5,200 other spectators they watched the Greensboro Whirlies beat the Gastonia Green Wave, 34-0.

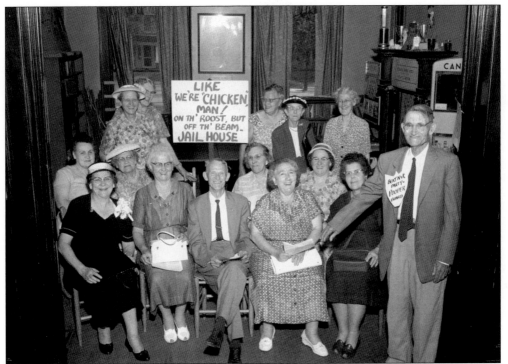

JULY 7, 1960. THURSDAY. GREENSBORO, NC. These unidentified senior citizens at the Greensboro Community Center on Arlington Street were caught up in the groovy, far out, hip "Beatnik" spirit of the late 1950s.

APRIL 1979. GREENSBORO, NC. Carol Martin was re-energized photographically in the 1970s when he began to spend his weekends and free time making images of the disappearing rural landscape in the Piedmont area, especially along NC 150 in Caswell County. He is seen here surrounded by some of these images, which were shot in color and initially displayed just in the studio's storefront window.

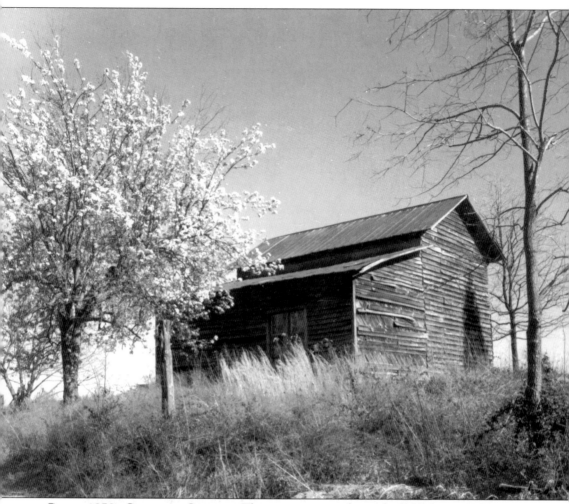

CIRCA 1978. GUILFORD COUNTY. This structure was located off Highway 68 in western Guilford County, near the old Bel-Aire golf club. Martin's rural photography is valuable both artistically and as visual documentation of the late 20th-century North Carolina landscape. His images received much wider exposure in the late 1970s when a regional McDonald's franchise owner and his decorator saw some of the prints in the studio window and immediately ordered copies for display in restaurants throughout the state.

SEPTEMBER, 1990. Carol Martin, in full photographic regalia, stands beside the studio's large 8x10 inch Deardorff camera. In 1990 the *Greensboro News & Record* sponsored a centennial photograph exhibit at the Greensboro Historical Museum and asked Martin to provide copies of images that had been given to him when he left the newspaper in 1947. This portrait by John Page formed part of the 1990 exhibit. Two years later, on June 17, 1992, Martin's Studio closed its doors for the last time. In his last interview with reporter Jim Schlosser, Martin offered "this town is full of great people," adding, "you must tell everyone that I had a damn ball the whole time I was in Greensboro." Carol W. Martin died on July 31, 1993. (*Courtesy of John Page.*)

INDEX

A
Ambrose, Lt. J.R., 19
American Motorcycle Association., races, 114
American Red Cross, 33
Aycock Junior High School, 49

B
Barber, Billy, 111
Barker, Sue Ellen, 60
Barnett, Bob (football), 31
Barnett, Bobo (clown), 119
Basketball, women's, 35
Belk's Dept. Store, construction, 98
Bennett College, 85
Berry, Mrs. Elizabeth V., 109
Black Cadillac Olds, 58
Blackledge, Wonder, 108
Boar and Castle, 80–81
Booth, Patricia, 111
Boone, Pat, 58
Bosher, Wilbur, grocery, 40
Broughton, J. Melville, 34
Burger King Restaurant, 82

C
Cameron Village (Raleigh), signage, 83
Candor, NC., 30
Cape Hatteras Lighthouse, 2
Carlson Farm, lake, 69
Carnegie Public Library, 105
Carolina Granite Co., 45
Carolina Circle Mall, future location of, 82
Carolinas Press Photographers Assoc., 36
Carolina Theatre, 95, 112
Cassidy, Hopalong (William Boyd), 57
Central Carolina Warehouse, 47
Central Carolina Convalescent Hospital, 122
Chapel Hill, NC., 11; FDR at Wollen Gym, 20; Franklin Street, 54
Charlotte, NC., Barringer Hotel, 52
Children's Home Society, football team, 27
Christmas parade, 57

Civil Defense, training, 48
Clemmer, Peggy, 35
Cloninger, Mrs. C.W., 112
Colvert, Mary Francis, 90
Cornwall, George, 111
Corrigan, Douglas, 19
Craddock, Billy "Crash," 59
Crawford, Elisha H., 34
Cribbin, Tom, 22
Croatan Sound, NC, 54

D
Davis, Elizabeth, 85
Daydreams (singers), 85
DeFelice, Jerry, 10
Dillard, E.C. "Ned," 24
Dr. IQ Quiz Show, 112
Driver, Bobby, 115
Durdan, Don, 31
Durham, NC, 31

E
Elam Beauty Shop, 40
Elks Club, 96

F
Farmer's Curb Market, 38
Farr, William B., daughters of, 65–66
Fletcher, Maria Beale, 72
Floods (1945), 36
Foster, Dorothy, 111
Foushee, Linda, 41
Foushee, Lorinda, 41
Fox hunting, 88–89
Fulton, Jim, 111
Frazier, Daniel, 26
Frazier, Glenn, 26
Frazier, Rufus, 26
Friendly Shopping Center, aerial, 71
Frog Gigging, 25, 26

G
Gallimore, Martha Ann, 111
Gardner, O. Max, 37

Girl Scouts, 25, 108
Greater Greensboro Golf Tournament, 12, 18, 22–23, 29
Greene, General Nathanael, statue, 120
Greensboro: Country Park, 54; Smith Homes, 75
Greensboro College, Finch Chapel, 90
Greensboro Community Center, 123
Greensboro Daily News, building, 100; carriers, 111; engraving dept., 27; linotype, 34; presses, 21
Greensboro Fairgrounds, 114
Greensboro Fire Department, central station, 21, 103
Greensboro Generals, 85
Greensboro Heart Association, 79
Greensboro High School (Grimsely), band, 118; hallway 41; dances, 55, 122; football, 60, 73
Greensboro Symphony Orchestra, 78
Greensboro War Memorial Stadium, 115
Greensboro Youth Center, 122
Guilford College, NC., 52, 121
Guilford County Courthouse, 94, 110
Guilford Dairy Bar, Summit Avenue, 77
Gulf, NC., floods, 36

H
Hale, Everett N., 21
Hamby, Walter W., daughter, 46
Harmon, Gen. Hubert R., 34
Haywood, David, 108
Hazelman, Herbert, 118
High Point, NC., swim meet, 18
Hoey, Clyde R., 37, 108
Hoey, Mrs. Clyde, 108
Hoey, Isabel, 108
Holiday Inn Motel, 59
Honey Dips Doughnuts, 79
Honey's Drive Inn, 76
Hughes, Meyressa, 60
Hunt, Joseph M., Jr., 74
Hunter, Parks, 6
Hunting, 88–89

I
Ice delivery, 116
Imperial Theatre, 116

J
Jefferson Standard Life Insurance Co., 64; clubhouse, 14

Johnson, Brenda, 85
Jones, Gwendolyn, 85

K
King Cotton Hotel, ballroom, 46, 99

L
Lack, Karl Heinz, 91
Lexington, NC., courthouse, 40
Lexington High School (NC.), football team, 27
Lions Club, brooms, 65
Little Crescent Railroad, 54
Lorillard Tobacco Co., York cigarettes, 73
Lost Colony (play), 56
Lowe's Hardware, 84
Lund, DeWayne "Tiny," 58
Lunsford Richardson Memorial Hospital, 44
Lutz, Bill, 58

M
McCoy, Edward, 74
McCoy, Robert, 74
McDonald, Jeanette, 112
McDonalds Restaurant, Northwood St., 78
Made-Rite Sandwich Co., 74
Manteo, NC., 53, 56
Martin, Carol W., 4, 9, 10, 11, 12, 123, 125
Miller, Malcolm A., 9, 11, 13, 14
Miss North Carolina, 72; contestants, 39
Mocksville, NC., county fair, 113
Morgenstern, Sheldon, 78
Moses Cone Hospital, 70; nurses station, 61
Murray, John, 85

N
NASCAR, drivers, 58
National Theatre, 114
Niles, Grover C. Jr., 10
Nixon, Richard M., 68
N.C. Debutante Ball, 9, 51
North State Chevrolet, 104
Northeast Shopping Center, 61
Nussbaum, Victor M., 71

O
O. Henry Hotel, 102, 112
Ocean Isle, NC., 77
Oettinger, L. F., 112
Oliver, Phyllis, 79
Overseas Replacement Depot (Greensboro, NC), 34, 47

P
Pappas, Harry, 20
Parker, Len, 108
Peach harvest, 30
Pecos Pete, 84
Pennsylvania Capital Airline, 37
Perry, Fred, 16
Piedmont Memorial Hospital, 95
Pinehurst, NC., 36
Polio epidemic, 122
Price, Julian, 109
Proximity YMCA, bowling, 67
Puritan Café, 20

R
Raines, Russell, 10
Raleigh, NC, 9, 108; Hillsborough St., 83
Refrigerators, 50, 117
Reidsville, NC., tobacco auction, 33
Remmey, E. M., 121
Ritchie, Mary Margaret, 37
Roosevelt, Franklin D., 20
Rose Bowl (Durham, NC), 31

S
St. Benedict Catholic School, band, 45
Sechriest, Stuart, 26
Sedgefield Horse Show, 53
Sedgefield Hunt, 87–89
Sedgefield Manor House, 55
Sewell, Nancy, 23
Shelby, NC, 37
Sikes, Dr. T. Edgar, farm, 82
Sills, Walter Harney, 76
Simkins, Dr. George, 75
Simmons, Madry, 26
Sky Castle, 60
Sloan, Harold, 111
Smith, Doris, 85
Smith Homes, Henry Louis, 75
Snead, Sam, 22
Southern Bell Building, 94
Spear, Samuel G., 44
Sewall, Nancy, 22
Stansill, Mrs. Thomas, baby, 117
Starmount Forest Country Club, 18, 29
Streets (Greensboro), S. Elm, 50, 83, 116;
 Spring Garden, 51; Walker at Elam, 40
Swimming, 18

T
Tanner, Mittie, 77

Taylor, Charles, 111
Taylor, John R., 59
Tennis, 16
Thompson Arthur Paving Co., 56
Tobacco industry, auction, 33; York
 cigarettes, 73
Tucker, Clarence N., 11, 15, 92
Tucker, Jim, 84
Turner, Lorene, 112

U
U.S. Army Air Force, 10, 19
Underwood, Dr. R. L., 112

V
Vines, Ellsworth, 16

W
Wachovia Bank Building, construction, 83
Wake Forest College, Wait Chapel, 57
Ward, Mrs. Ben C., daughter, 47
WBIG, radio station, 45
Wesley Long Hospital, 102
West Market Street Methodist Church, 105
Western Auto Co., merchandise show, 46
Western Electric Co., 48
Wimbish, S. Graham, 38
Wine, William, 38
Winston-Salem, NC., 27
Woman's College (UNCG), 35
Wootten, Bayard, 36
World War II, basic training, 32; blackouts,
 114; bond drive, 109; Red Cross, 33;
 scrap drives, 31, 111; victory gardens,
 32; VJ night, 35; VJ parade, 113
Wrightsville Beach, NC., 39
Wyman, Jane, 109

Z
Zenke, Otto, 52

NOTE: Researchers can find an extensive bibliography on Greensboro and Guilford County on the Museum Archives web site. The "Local History Reader" page is currently under "Highlights."

www.greensborohistory.org/archives